Diane Phalen

Quilts *from a* Painter's Art

Landauer Books

Diane Phalen's Quilts from a Painter's Art
Copyright © 2004 by Landauer Corporation
Art Copyright © 2004 Diane Phalen

This book was designed and produced by Landauer Books
A division of Landauer Corporation
12251 Maffitt Road, Cumming, Iowa 50061

President and Publisher: Jeramy Lanigan Landauer
Director of Operations: Kitty Jacobson
Editor-in-Chief: Becky Johnston
Creative Director: Laurel Albright
Quilt and Project Designers: Retta Warehime and Jill Reber
Technical Illustrator: Linda Bender
Technical Editor: Jill Reber
Photostylist: Jill Reber
Photographers: Craig Anderson, Dennis Kennedy
Professional Quilting: Pam Clarke
Printed in Hong Kong

This book is printed on acid-free paper.

1 2 3 4 5 6 7 8 9 10

Library of Congress Cataloging-in-Publication Data

Beginnes-Phalen, Diane, 1953-
 Quilts from a painter's art / Diane Phalen.
 p. cm.
 ISBN 1-890621-75-7
 1. Patchwork--Patterns. 2. Quilting. 3. Watercolor painting, American--Reproduction. 4.
 Beginnes-Phalen, Diane, 1953---Adaptations. I. Title.

TT835.B33224 2004
746.46'041--dc22
 2004048501

INTRODUCTION

Watercolorist Diane Beginnes-Phalen is best known for her popular Americana quilt series—a vibrant collection of paintings featuring flowers, cottages, barns, country stores and Amish country life, with a rainbow of quilts hanging from porch rails, clotheslines and fences. Diane's fascination with quilts stems from her childhood, growing up in Bethlehem, Pennsylvania. As a Pennsylvania native, Diane grew up in the midst of gentle rolling hills and the beauty and simplicity of the rural Pennsylvania countryside.

Most important to Diane is to be able to convey emotion in painting and she enjoys painting the quilts in their beautiful seasonal surroundings. Diane's wish is for her viewers to be able to feel the summer day, the wind, or any other aspect of a painting. She wants the scent of the flowers to be present, the mood of an autumn sky or winter sunset, a moment of peace and contentment connecting nature with our heritage and values. For Diane, the viewer's eye should move through each painting to discover delightful, hidden elements like a butterfly on a bush or a cat resting among garden blossoms.

Although Diane Phalen rarely picks up a needle she has created more than 90 original quilts. Her paintbrush is comparable to a threaded needle. Traditional quilt block patterns such as Dresden Plate, Log Cabin, Pinwheel, and Flying Geese are a few of the endless possibilities for quilt designs—and Diane would like to paint them all. Diane is often heard to say, "I quilt with my paintbrush."

Diane Phalen

The 28 quilts and projects featured in the following pages were adapted from Diane's original paintings by professional quilt designers, Retta Warehime and Jill Reber. Fabric selections were inspired by the vivid hues of the watercolor quilts scattered throughout Diane's paintings.

Many of the quilts feature traditional quilt block patterns. Choose from a variety of block patterns to create quilts and home decorating accessory projects. Step-by-step instructions with illustrations and full-size patterns make it a breeze to complete the inspirations you'll find on the following pages.

For Diane, the Americana quilt series will continue to be an ongoing love affair. She feels that, "The quilts are such a part of my emotion and heritage; they curl around me with their warmth and the images of my memories of Pennsylvania, family and home."

Discover how easy it is to fall in love with *Quilts from a Painter's Art* and the joys of making lasting memories from your own quilted masterpieces.

From Diane's art to your heart,

Becky Johnston

Editor-in-Chief

CONTENTS

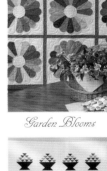
Garden Blooms

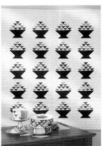
Spring Basket

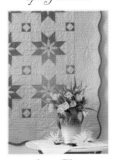
Star Flower

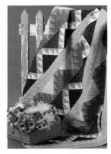
Indian Trails

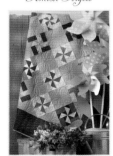
Log Cabin Comfort

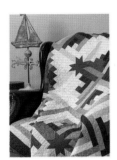
Amish Flight

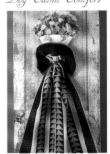
Patchwork Pinwheels

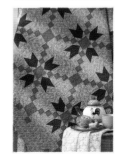
Holiday Cheer

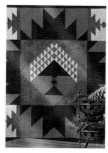

Mountain Majesty

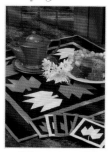

Spring Breeze

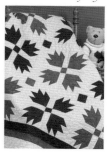

Maple Leaf Mist

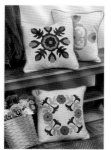

Floral Fantasy

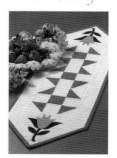

Picket Fence Petals

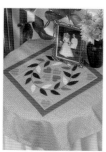

Bridal Wreath

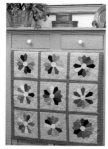

Meadow Flowers

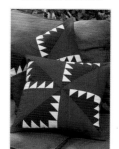

Bear Tracks

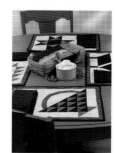

Summer Sampler

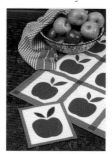

Apple Harvest

GENERAL INSTRUCTIONS

FOR EVERY PROJECT:

Here are some guidelines for gathering your materials for each of the projects in this book:

■ For best results use good quality 100% cotton fabrics. These should measure between 42" and 44" wide.

■ Scraps of fabric are intended to be those that you have on hand. If you should need to purchase these, 1/8 yard pieces or fat eighths will work, unless noted otherwise. See the size chart below for sizes of fabrics:

1/8 yard cut	4 1/2" x 44" rectangle
Fat Eighth	9" x 22" rectangle
1/4 yard cut	9" x 44" rectangle
Fat Quarter	18" x 22" rectangle

■ If you prefer you may pre-wash fabrics for these projects, but it is not necessary. It is a good idea to test red and other colored fabrics for bleeding. Place a scrap of fabric in a glass or bowl of hot water. If you see a color change in the water, you may want to pre-wash that particular fabric. You should rinse until the water runs clear, then line or machine dry and press.

■ Use a rotary cutter, rotary ruler and mat to cut fabric strips. Cut the fabric strips into squares, rectangles and triangles as directed in each pattern.

■ All seam allowances are 1/4" unless noted otherwise.

■ Press seams in one direction following arrows if indicated. If no arrows are indicated, press seam towards the darker fabric.

HAND APPLIQUÉ:

■ Using template plastic or freezer paper, trace around each appliqué shape and cut out.

■ Draw around template onto right side of desired fabric using pencil, chalk pencil or washable sewing marker.

■ Cut out appliqué 1/4" beyond traced line.

■ If layers of appliqué are needed, begin working at the background and work forward.

■ Using the drawn line as your guide, slip stitch the appliqué into place. Use your needle to fold under the seam allowance. Take a 1/8" stitch down through the background fabric. Bring the needle up through the fold of the appliqué catching a few threads of the appliqué fabric. Insert the needle as close as possible to where it came up and continue for the entire appliqué shape.

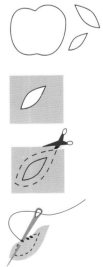

MACHINE APPLIQUÉ:

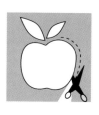

■ Using lightweight fusible web, follow the manufacturer's instructions for tracing and fusing:

■ Trace the appliqué shape onto the paper side of the fusible web. Cut the fusible web about 1/8" from the outside traced line.

■ Fuse the pattern to the wrong side of desired fabric. Cut out on the traced line. Transfer any dashed placement lines to the fabric.

■ Peel off the paper backing. Position the appliqué on the background fabric, overlapping the pieces at the dashed lines. Fuse in place. Machine stitch using a zig-zag or buttonhole stitch.

FINISHING THE QUILTED PROJECTS:

LAYERING

■ Cut the backing and batting 4" to 6" inches larger than the finished quilt top.

■ Lay backing wrong side up on a smooth flat surface. Secure the edges with tape. Center the batting over the backing. Smooth the batting out. Layer the quilt top in the center of the batting. Smooth the quilt top out.

■ Baste with large running stitches or small safety pins every 4". Begin in the middle and work out to the edges.

■ Trim edges of the batting and backing even with the quilt top after the quilting has been completed.

QUILTING

BY HAND

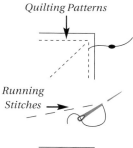

Quilting Patterns

Running Stitches →

■ Using hand quilting thread; thread a quilting needle with an 18" length of thread. Tie a small knot at the end. Insert the needle through the quilt top and into batting about 1" from where you want to begin quilting. Bring the needle up at the beginning of the quilting line. Give the thread a gentle tug to pull the knot through the quilt top and down into the batting.

■ Take several small running stitches at a time, keeping stitches even and as close together as possible (1/8" to 1/4").

Clip

■ To end a line of stitching, make a small knot close to the fabric. Insert the needle into the fabric and bring it out again about 1" from the end of the stitching. Pop the knot through the quilt top into the batting and clip the thread close to the quilt top.

BY MACHINE

■ Check your sewing machine manual for help with these tips:

■ Use a walking foot for straight stitching of quilting lines. This will help to keep all layers of the quilt even. Pivot the fabric by keeping the needle in the down position when changing directions.

■ Quilting stencils may be used for all types of designs. The embroidery or darning foot and lowering the feed dogs is helpful for this style of quilting.

- A sleeve for hanging is added to the back of the quilt after the quilting has been completed and before the binding is applied.

- Cut a strip 5-1/2" wide and 1" shorter than the finished width of the quilt.

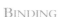

- Press under a 1/2" hem and then 1/2" again, on each of the short sides. Topstitch the hem in place.

- Press the hanging sleeve in half lengthwise. Pin the strip to the top backside of the quilt, with raw edges even. The raw edges will be covered by the binding. Baste in place with a 1/4" seam allowance.

- After the binding is attached and sewn to the quilt, smooth and pin the hanging sleeve to the back. Slip stitch to the back of the quilt, taking care to only go through the back and batting layers of the quilt.

BINDING

Bias Binding (for rounded or scalloped-edge quilts)

- Working from 18" x 44" piece of fabric, align and cut a 45° angle on one edge of the strip.

- Measure 2-1/2" wide strips from the cut edge. Cut enough strips to fit the outside edge of your finished quilt.

- Seam strips together.

- Fold Bias Binding in half lengthwise, wrong sides together and press. Handle Bias Binding carefully so as not to stretch it.

- Unfold one end and fold so that it is at a 45° angle. Turn under the edge 1/4" and press. Refold strip.

- Align the raw edges of the Bias Binding on the top of the quilt at the scalloped edge. Pin if desired. Using a walking foot, stitch with a 3/8" seam allowance, starting 2" from the angled end. Work carefully around the scalloped edges making sure to not pull the Bias Binding tight.

- Continue around the outside of the quilt working your way back to the beginning. Trim the end of the Bias Binding and tuck it into folded angled edge. Sew through all layers to where stitching started.

- Fold the Bias Binding around to the backside of the quilt and slip stitch into place, just covering the stitching line.

Cross-Grain Binding (for straight edge quilts)

■ Cut 2-1/2" x 44" strips of fabric. Cut enough strips to fit the outside edge of your finished quilt. Allow extra length to allow for diagonal piecing.

■ Diagonally piece strips together.

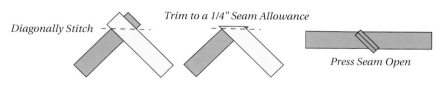

Diagonally Stitch *Trim to a 1/4" Seam Allowance* *Press Seam Open*

■ Fold Cross-Grain Binding in half lengthwise, wrong sides together and press.

■ Unfold Cross-Grain Binding and fold down strip at 45° angle. Trim off even. Refold and press strip.

Trim

■ Align the raw edges of the Cross-Grain Binding on the top of the quilt at the trimmed edge. Pin if desired. Using a walking foot, stitch with a 3/8" seam allowance, starting 2" from the angled end.

■ To miter the Cross-Grain Binding at the corners; stop stitching 3/8" from the corner of the quilt top. Pivot and stitch off the edge of the quilt.

■ Fold the Cross-Grain Binding up along the stitched line. Then fold the Cross-Grain Binding back down and even with the corner edge of the quilt. Begin stitching at the edge. Repeat to miter all corners of the quilt.

■ Continue around the outside of the quilt working your way back to the beginning. Trim the end of the Cross-Grain Binding and tuck it into folded angled edge. Sew through all layers.

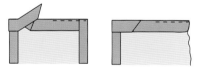

■ Fold the Cross-Grain Binding around to the backside of the quilt and slip stitch into place, just covering the stitching line.

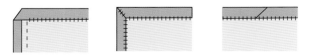

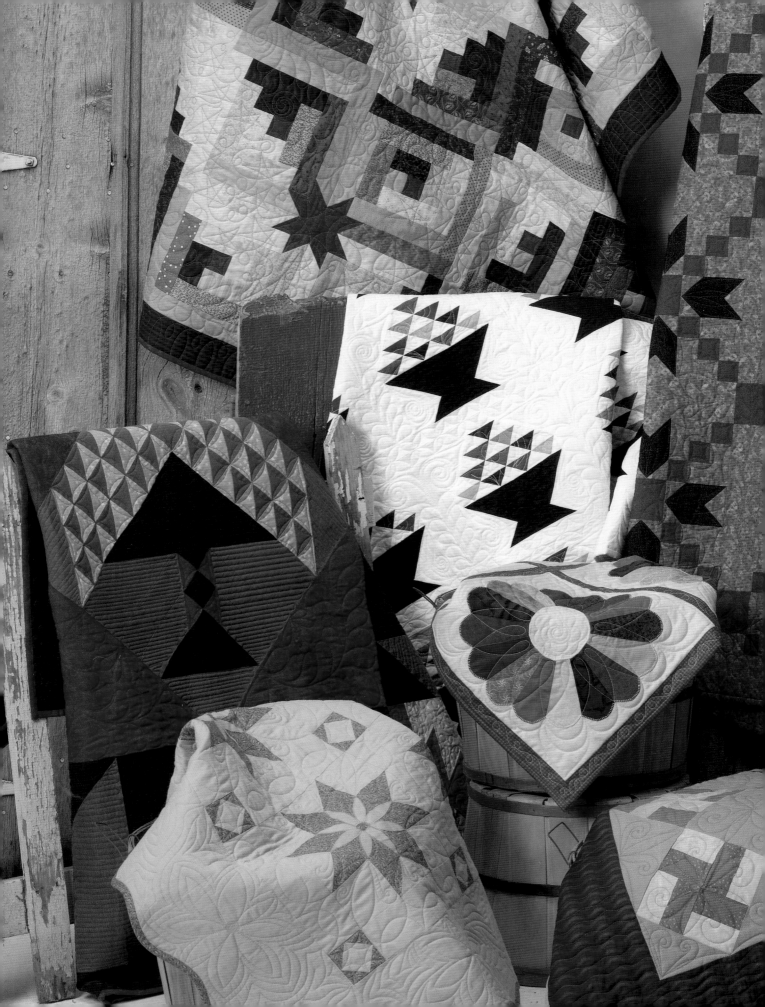

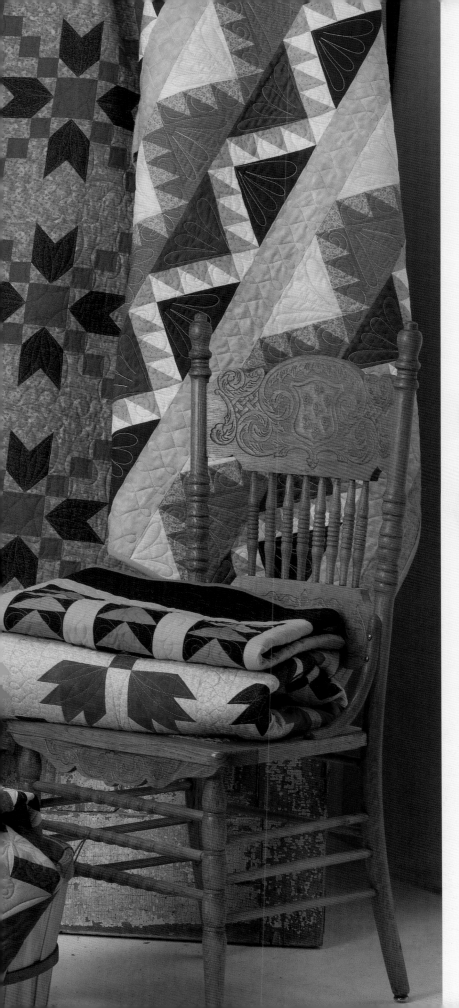

THE QUILTS

Choose from an impressive array of quilts with fabric selections inspired by the vivid hues of the watercolor quilts scattered throughout Diane's paintings.

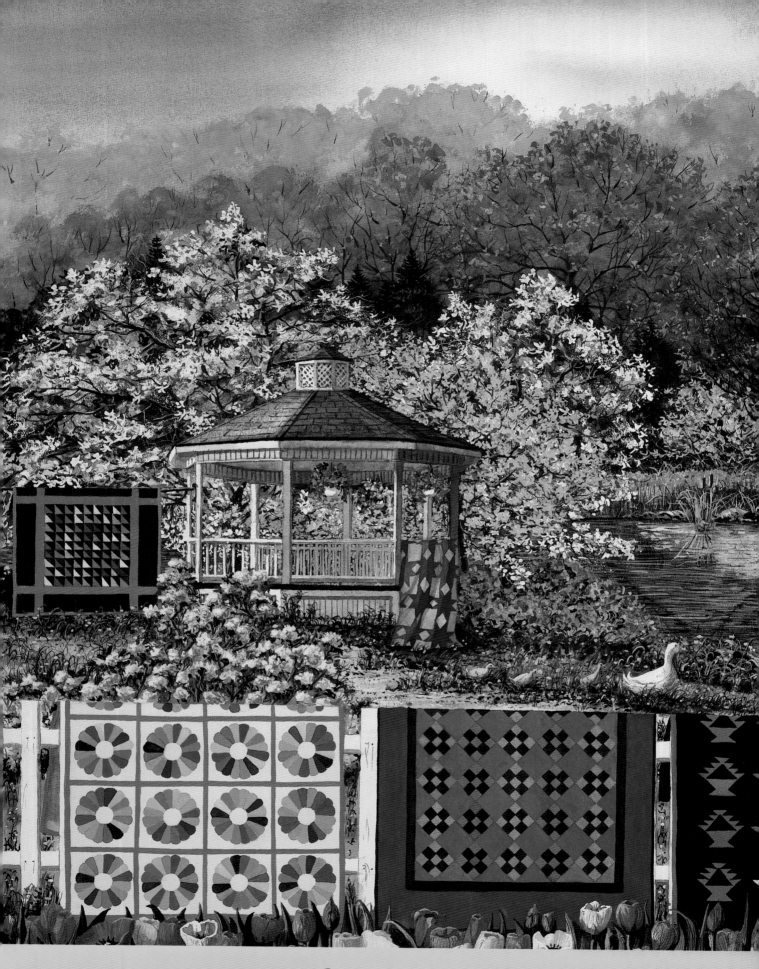

Spring Garden

The Quilts

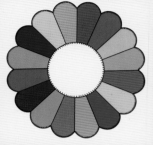

Garden Blooms

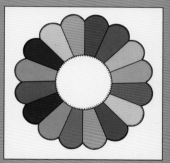
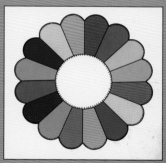

Gathered in the garden

and gracing the gazebo,

quilts with classic block patterns

such as the Dresden Plate set

the scene for a springtime

floral masterpiece.

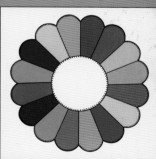
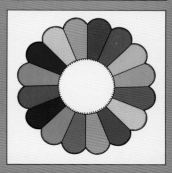

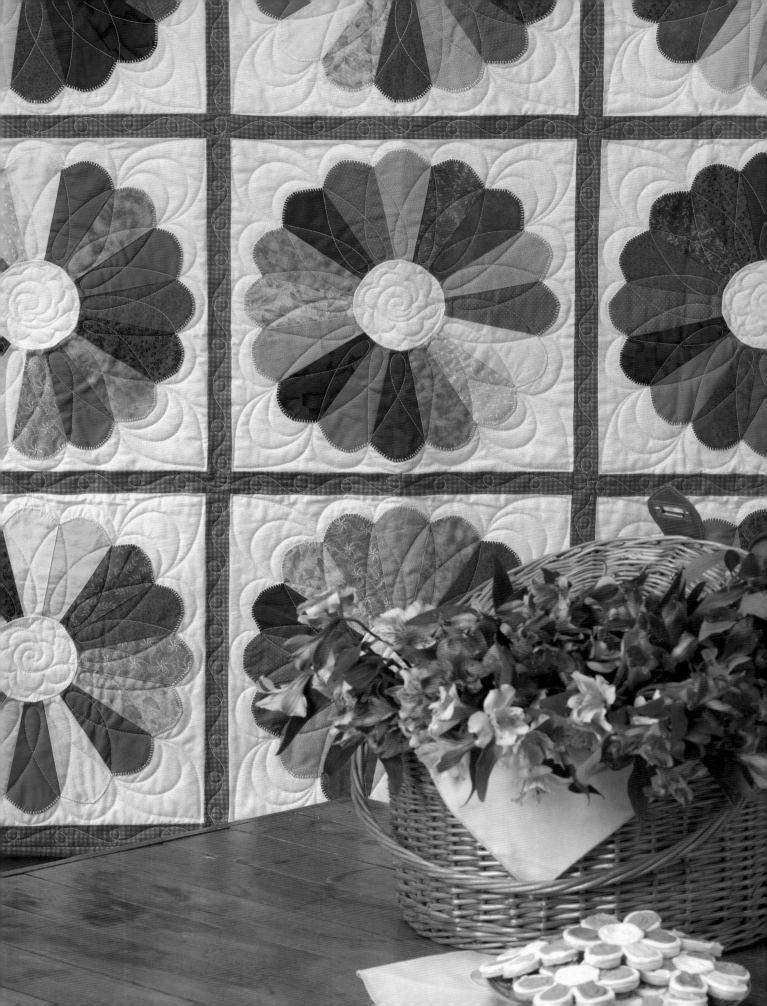

Garden Blooms

Approximate finished size of quilt:
46"x 61"

Materials

2 yards of scraps for
Dresden Plate pieces
(*or* 20 fat eighths or 10 fat quarters)

2-1/2 yards of yellow
background fabric

1-1/4 yards of red fabric for
sashing, borders and binding

3 yards of backing fabric
(seamed to fit)

Cotton batting to fit finished top

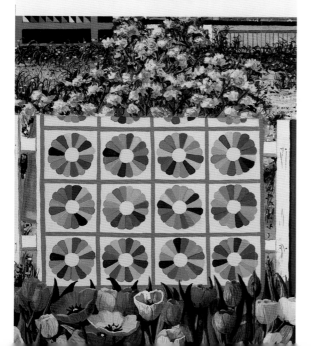

Dresden Plate Block

Block finished size: 14" x 14"

Make 12 Blocks

Cutting

- From the scraps of fabric cut:
 192—Template A pieces (on page 17)
 (16 pieces per block)

- From the yellow background fabric cut:
 24—Template B pieces (on page 17)
 (2 pieces per block)
 12—16" squares

Piecing the Blocks

1. Using 1⁄4" seam allowances place fabric right sides together. Randomly join Template A pieces by twos, fours and eights to make 24 half Dresden Plate Blocks. Press seams in one direction. Join halves to make 12 Dresden Plate Blocks. Press. Baste around center to prevent stretching.

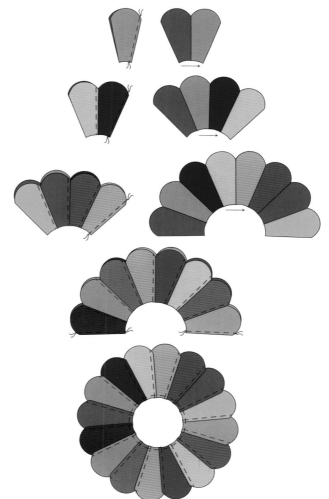

Assembling the Blocks

1. Center and pin each Dresden Plate Block right side up to a yellow 16" square. Turning under raw edges at outside edge only, hand or machine buttonhole stitch.

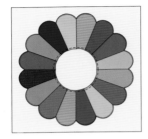

2. For each Dresden Plate, place two Template B pieces right sides together. Slash one piece as shown and stitch around the outside edge. Turn right side out through opening. Press, using a pin to pull out the seam line.

3. Place Dresden Plate center slash side down on right side of Dresden Plate Block. Pin and hand or machine buttonhole stitch each Dresden Plate center to the Dresden Plate Block.

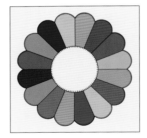

4. If necessary, trim each Dresden Plate Block to a 14-1/2" square.

Assembling the Sashing and Borders

- From the red fabric cut:
 8—1-1/2" x 14-1/2" rectangles
 6—1-1/2" x 44" strips

1. Arrange blocks three across by four blocks down. Sew a 1-1/2" x 14-1/2" rectangle between each block in the horizontal row.

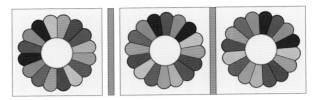

2. Seam the six strips as needed to make five 1-1/2" x 44-1/2" sashing strips and two 1-1/2" x 61-1/2" border strips. Align and sew horizontal rows with three sashing strips, to form the quilt top. Sew the two remaining sashing strips to the top and bottom of the quilt top, for the top and bottom borders.

3. Sew the two 1-1/2" x 61-1/2" border strips to the sides of the quilt top.

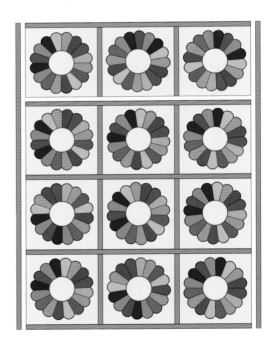

Finishing the Quilt

1. Layer quilt top with batting and backing. Quilt as desired.

2. Refer to General Instructions to bind the quilt with red fabric.

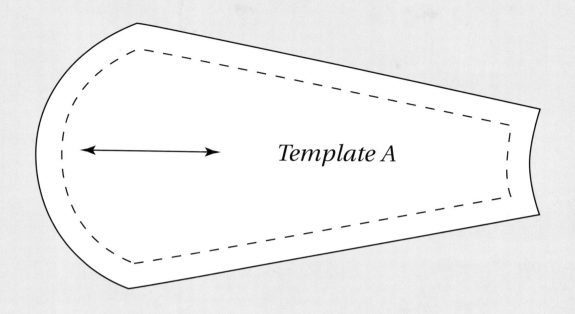

Template A

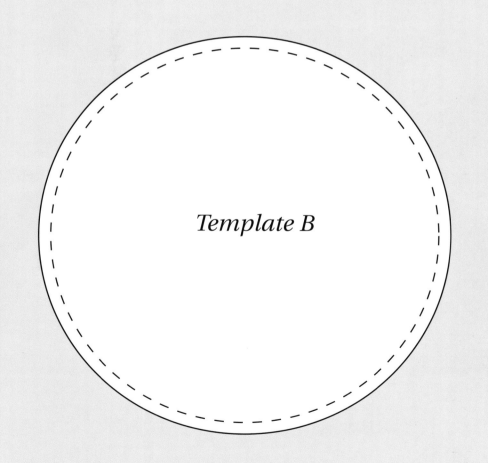

Template B

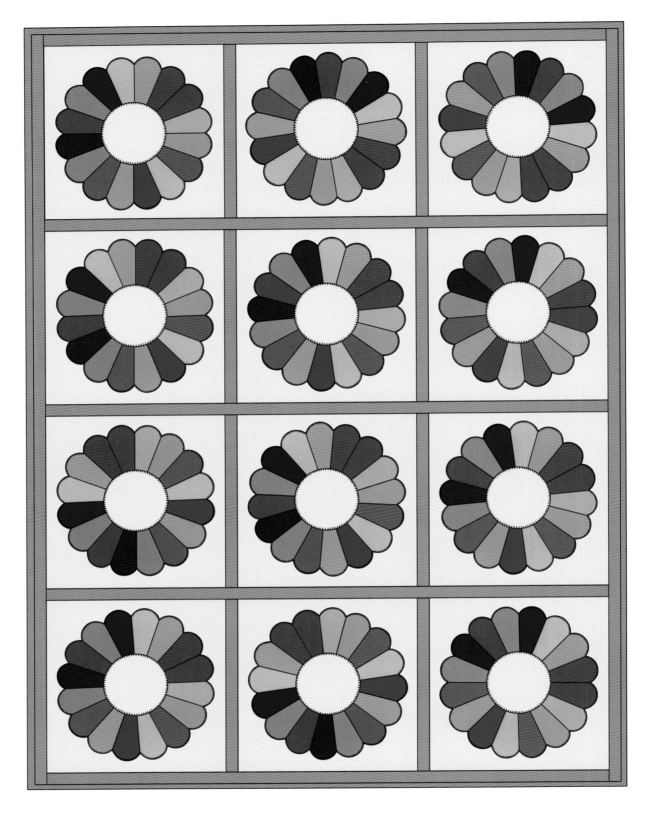

Garden Blooms Quilt

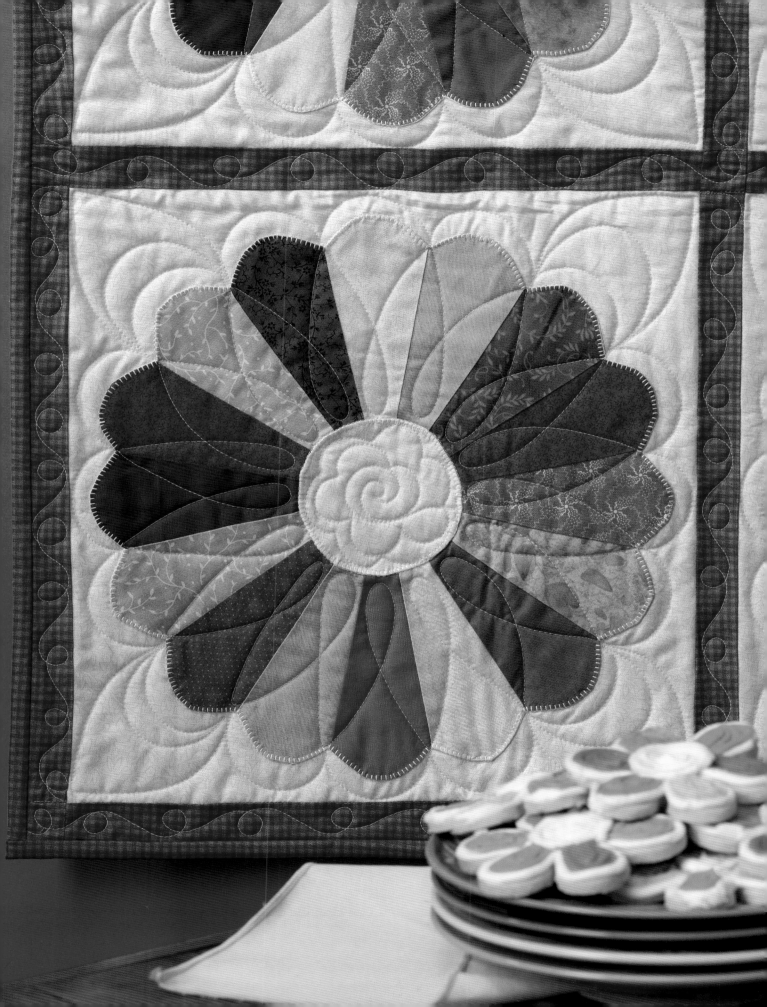

Amish Spring

The Quilts

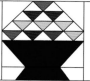

Spring Basket

Blooms in basket blocks

are bountiful on a

soft-as-springtime quilt

that blows gently in

the flower-scented breeze.

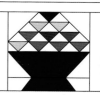
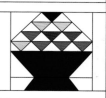
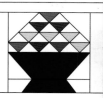
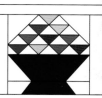
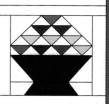
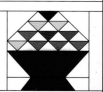

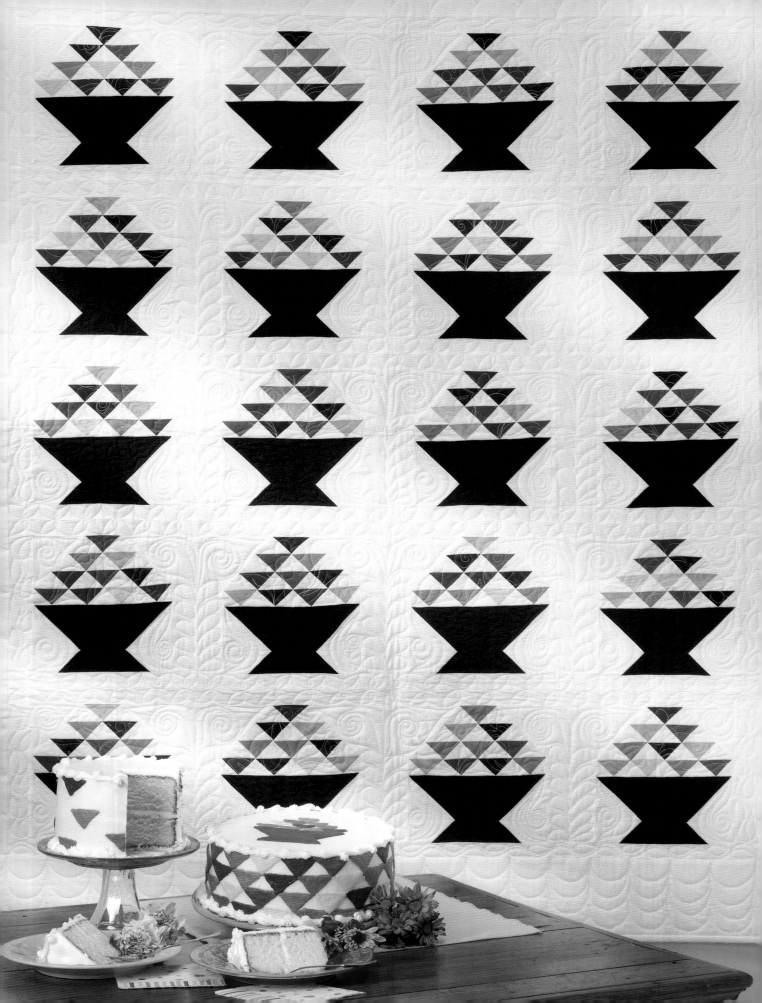

Spring Basket

Approximate finished size of quilt:
56" x 62-1/2"

Materials

1 yard of dark blue fabric
for basket bottoms

1/4 yard each of five assorted
fabrics for basket tops

5 yards of white fabric
for background and binding

❖

3-5/8 yards of backing fabric
(seamed to fit)

❖

Cotton batting to fit finished top

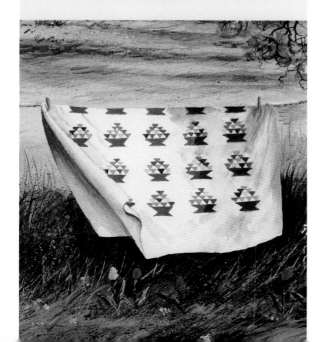

Basket Block

Block finished size: 10-1/2" x 11-1/2"

Make 20 Blocks

Cutting

- From the dark blue fabric for basket bottoms cut:
 20—3-3/8" x 9" rectangles
 20—1-7/8" x 6" rectangles

- From each of the 5 assorted fabrics for basket tops cut:
 20—2-3/8" squares, cut in half diagonally once to make
 40—2-3/8" half-square triangles (200 total)

- From the white fabric cut:
 1—2" x 44" strip; from the strip, cut:
 20—2" squares, cut in half diagonally for
 40—2" half-square triangles
 7—2-3/8" x 44" strips; from these strips, cut:
 120—2-3/8" squares, cut in half diagonally to make
 240—2-3/8" half-square triangles
 6—3-3/8" x 44" strips; from these strips, cut:
 40—3-3/8" squares and
 40—1-7/8" x 3-3/8" rectangles
 3—4-1/8" x 44" strips; from these strips, cut:
 20—4-1/8" squares, cut in half diagonally for
 40—4-1/8" half-square triangles
 2—12" x 44" strips; from these strips, cut:
 40—1-1/2" x 12" rectangles
 2—9" x 44" strips; from these strips, cut:
 40—1-1/2" x 9" rectangles

Piecing the Basket Bottom

1. Draw a diagonal line from corner to corner on the wrong side of each of the 40 white 3-3/8"squares.

2. Right sides together, position a white square on each end of the dark blue 3-3/8" x 9" rectangles. Stitch on the drawn line. Trim seam allowance to 1/4". Press. Repeat for other side.

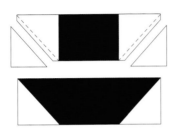

Make 20

3. Right sides together, position a 1-7/8" x 3-3/8" white rectangle on the 1-7/8" x 6" dark blue rectangle, as shown. Draw a diagonal line. Stitch on the drawn line. Trim seam allowance to 1/4". Press. Repeat for other side. Make 20.

Make 20

4. Using a 1/4" seam allowance, sew the two Basket Bottom units together.

Make 20

Piecing the Basket Top

1. Using a 1/4" seam allowance, sew 180 of the 2-3/8" white fabric and 180 of the assorted colors half-square triangles into triangle squares as shown.

Make 180

2. For each block, using randomly placed triangle squares and the remaining white and assorted colors half-square triangles, sew the following rows:

 • Row 1: Add one 2-3/8" assorted color half-square triangle and one 2" white half-square triangle.

 • Row 2: Add one 2-3/8" white half-square triangle.

 • Row 3: Add one 2-3/8" white half-square triangle.

 • Row 4: Add one 2-3/8" white half-square triangle and one 2" white half-square triangle.

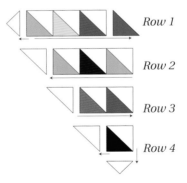

3. Sew rows together. For each block, sew one 4-1/8" white half-square triangle to each side of the Basket Top.

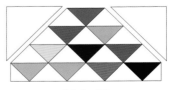

Make 20

Assembling the Block

1. Sew the Basket Top to the Basket Bottom.

2. Sew a 2" x 9" white rectangle to each side of each basket. Sew a 1-1/2" x 12" white rectangle to the top and bottom of each basket.

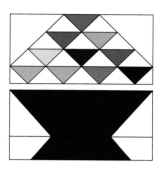

Make 20

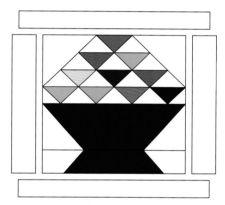

Make 20

3. Block should measure 12" x 11" to each unfinished edge.

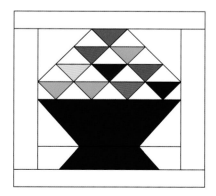

Assembling the Quilt Top

1. Sew five horizontal rows of four baskets. Press seams in alternating directions.

2. Sew rows together. Press seams in one direction.

Adding the Borders

Cutting

- From the white fabric cut:
 6—5-1/2" x 44" strips

1. Seam the six strips as needed to make two 5-1/2" x 53" border strips for the sides of the quilt and two 5-1/2" x 56-1/2" border strips for the top and bottom of the quilt top. Sew border strips to quilt sides, top and bottom.

Finishing the Quilt

1. Layer quilt top with batting and backing. Quilt as desired.

2. Refer to General Instructions to bind quilt with white background fabric.

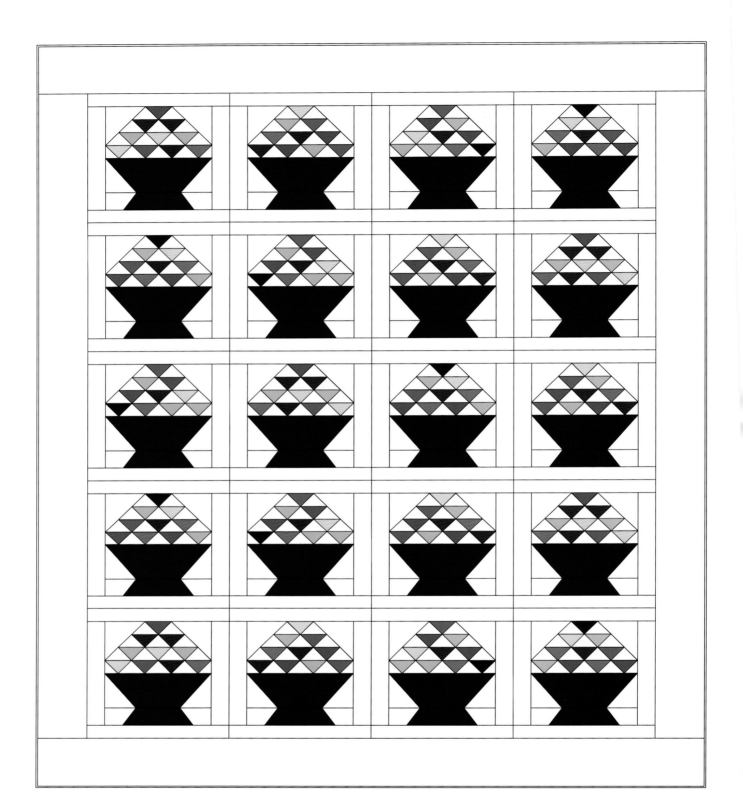

Spring Basket Quilt

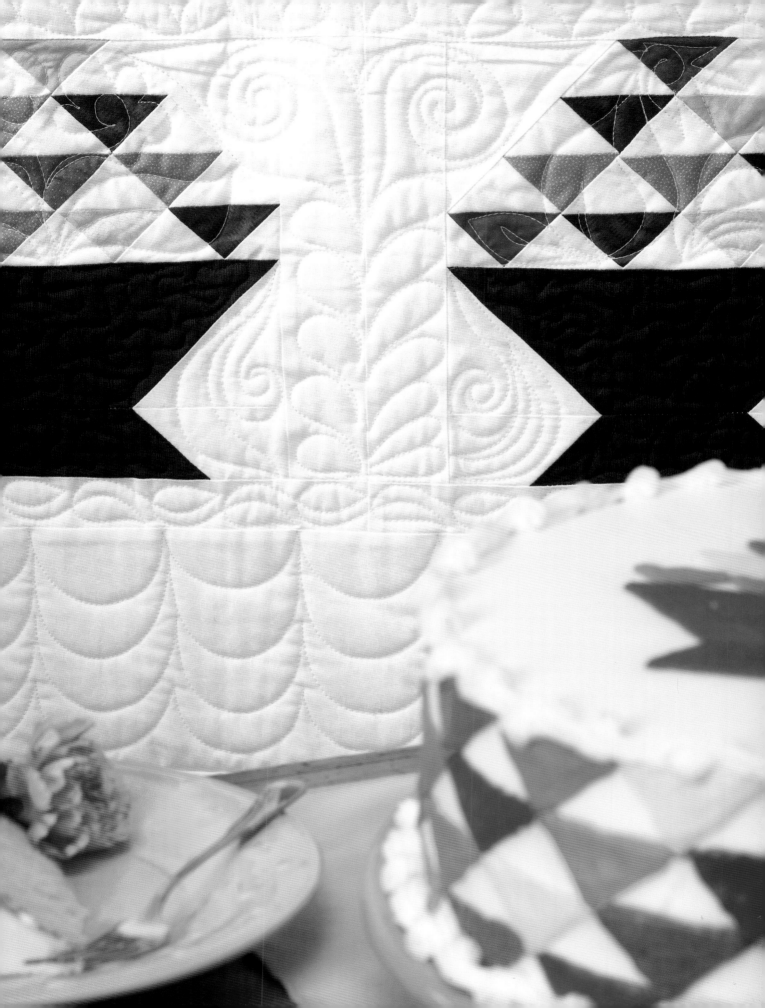

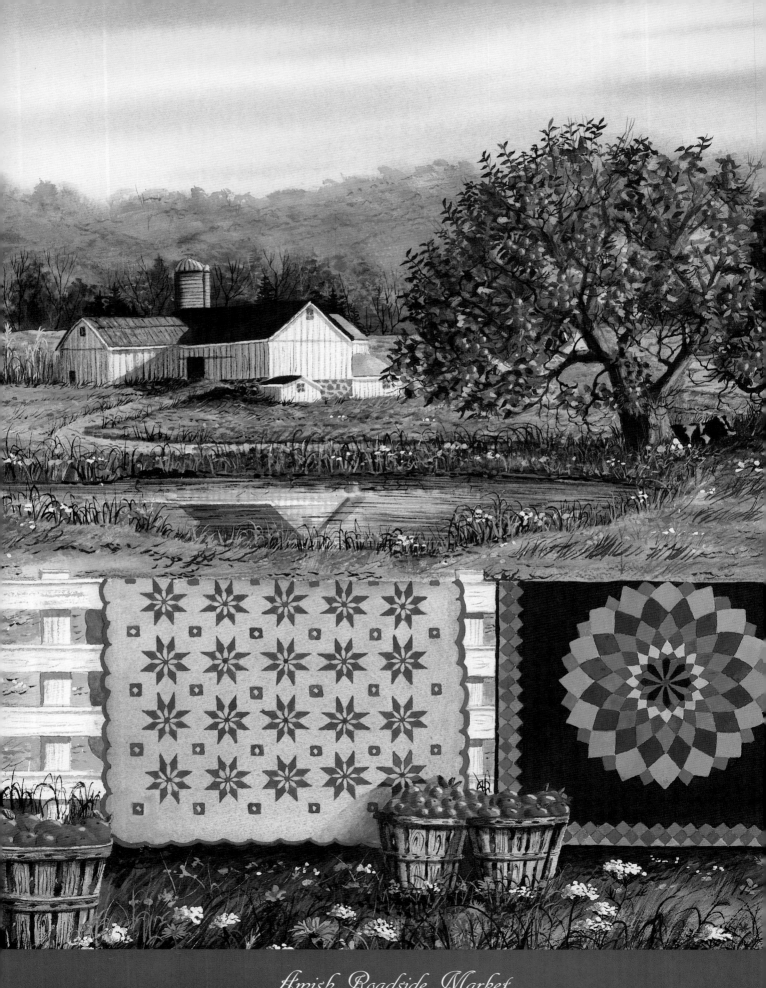

Amish Roadside Market

Star Flower

Set in a scalloped-edge quilt,

star flowers in subtle

shades of blue lend tranquil

serenity to a field of dreams.

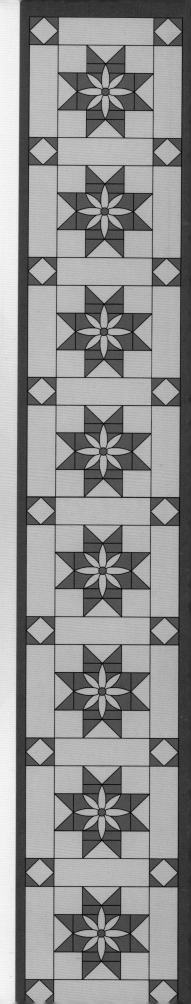

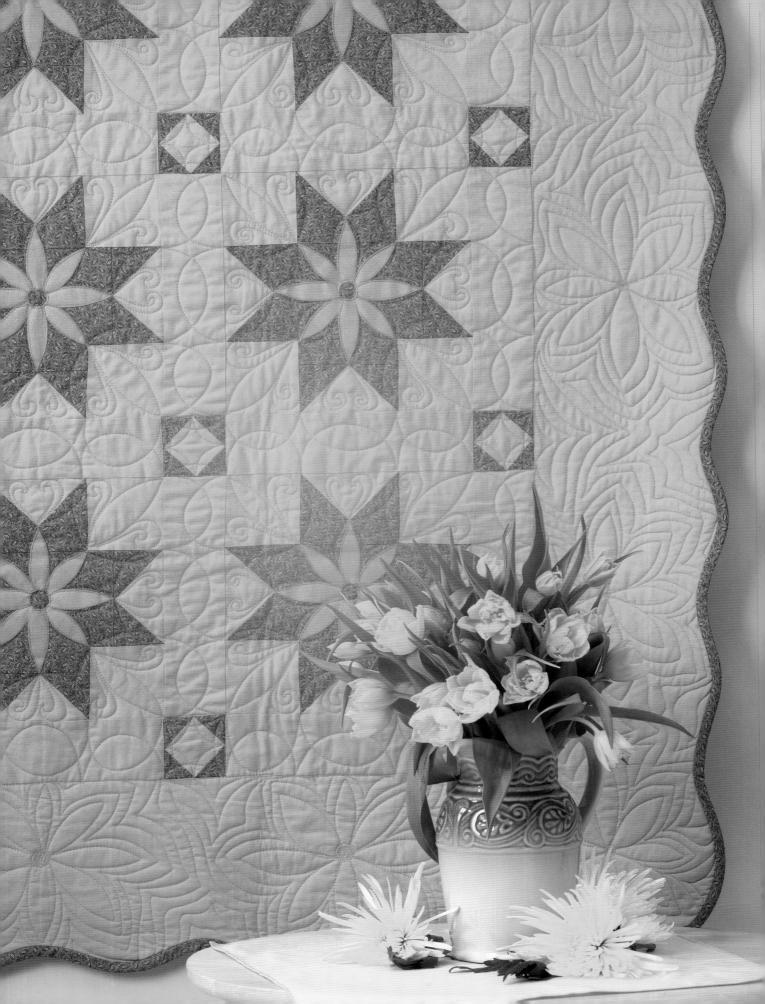

Star Flower

Approximate finished size of quilt:
46" x 60-1/2"

Materials

4 yards of light blue fabric
for background, appliqué,
borders and sashing

2-1/2 yards of dark blue fabric
for stars and binding

1 yard fusible web (optional)

3-1/2 yards of backing fabric
(seamed to fit finished top)

Cotton batting to fit finished top

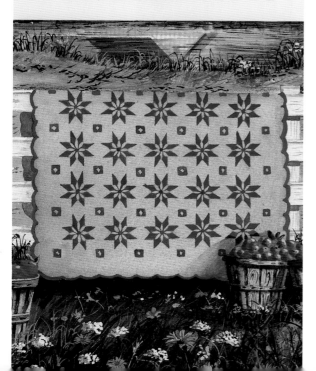

Star Flower Block

Block finished size: 10" x 10"

Make 12 Blocks

Cutting

- From the light blue fabric cut:
 4—3-1/2" x 44" strips; from these strips, cut:
 48—3-1/2" squares
 3—4-1/2" x 44" strips; from these strips, cut:
 2-1/2" x 4-1/2" rectangles
 48—Template A pieces (on page 34)
 48—Template B pieces (on page 34)

- From the dark blue fabric cut:
 5—2-1/2" x 44" strips; from these strips, cut:
 96—2-1/2" squares
 4—4-1/2" x 44" strips; from these strips, cut:
 24—1-1/2" x 4-1/2" rectangles
 12—4-1/2" x 6-1/2" rectangles

Assembling the Star Flower Block

1. Draw a diagonal line from corner to corner on the wrong side of each of the 96—2-1/2" dark blue squares.

2. Right sides together, place a dark blue square on the right side of a light blue 2-1/2" x 4-1/2" rectangle to make the star points. Stitch on the drawn line. Trim seam allowance to 1/4". Press. Repeat for other side.

Make 48

3. Sew the 24—1-1/2" x 4-1/2" dark blue rectangles to 24 star points. Sew a light blue 3-1/2" square to each side of each star point. Press seams as shown.

4. Sew the remaining 24 star points to the sides of each of the 12—4-1/2" x 6-1/2" rectangles. Press seams as shown.

Row 2

5. Assemble 12 Star Flower Blocks combining one Row 2 with two Row 1. Press seams away from center of block.

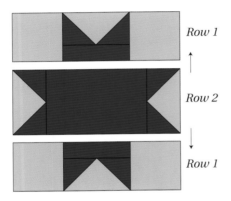

Row 1

Row 2

Row 1

6. Refer to General Instructions for hand or machine appliqué for petals in center of block. Using four each per block, appliqué large petals horizontally and vertically and small petals diagonally to center of block. If needed, trim centers before appliquéing in place.

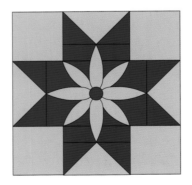

Corner Stones and Sashing

Make 20 Corner Stones

Cutting

- From the light blue fabric cut:
 2—3" x 44" strips; from these strips, cut:
 20—3" squares
 8—3" x 44" strips; from these strips, cut:
 31—3" x 10-1/2" rectangles

- From the dark blue fabric cut:
 4—1-3/4" x 44" strips; from these strips, cut:
 80—1-3/4" squares

Assembling the Corner Stone Units

1. Draw a diagonal line from corner to corner on the wrong side of the 80—1-3/4" dark blue squares.

2. Right sides together, place a dark blue square on the opposite corners of a light blue 3" square, as shown. Stitch on the drawn line. Trim seam allowance to 1/4". Press. Repeat for other side.

Adding the Sashing

1. Sew five sashing rows using 20 Corner Stones, and light blue 3" x 10-1/2" rectangles, as shown.

2. Sew four Star Flower Block rows together with the remaining 3" x 10-1/2" sashing rectangles.

3. Sew sashing rows to Star Flower Block rows.

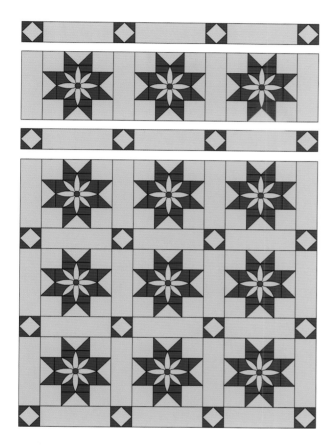

Adding the Borders

NOTE: Cut scallops after you complete quilting.

• From the light blue fabric cut:
 6—10" x 44" strips

1. Seam the strips as needed to make two 10" x 53" border strips. Sew to the sides of quilt top.

2. Seam the strips as needed to make two 10" x 59" border strips. Sew to top and bottom of quilt top.

Marking the Scallops

1. From freezer paper cut Templates C and D (page 34) and join to make a complete pattern for the side of your quilt top.

2. Lay bottom of freezer paper pattern 6" from the top and sides of quilt top. With a fabric pencil, transfer scallop lines onto the border. Start with the corners, coming directly out from the Corner Stone. Position six Scallops on the top and bottom of quilt top. Position eight Scallops on each side of quilt top. Scallops may need some adjusting.

Finishing the Quilt

1. Layer quilt top with batting and backing. Quilt as desired. Cut Scallops as drawn on quilt top.

2. Refer to General Instructions to bind quilt with dark blue fabric using the Bias Binding method.

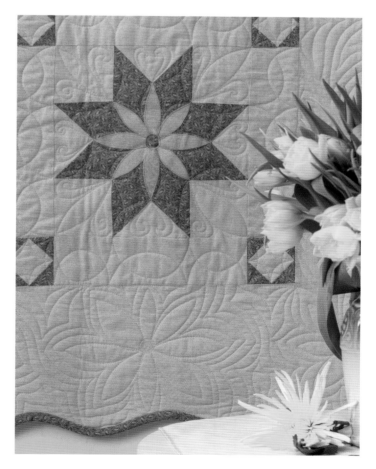

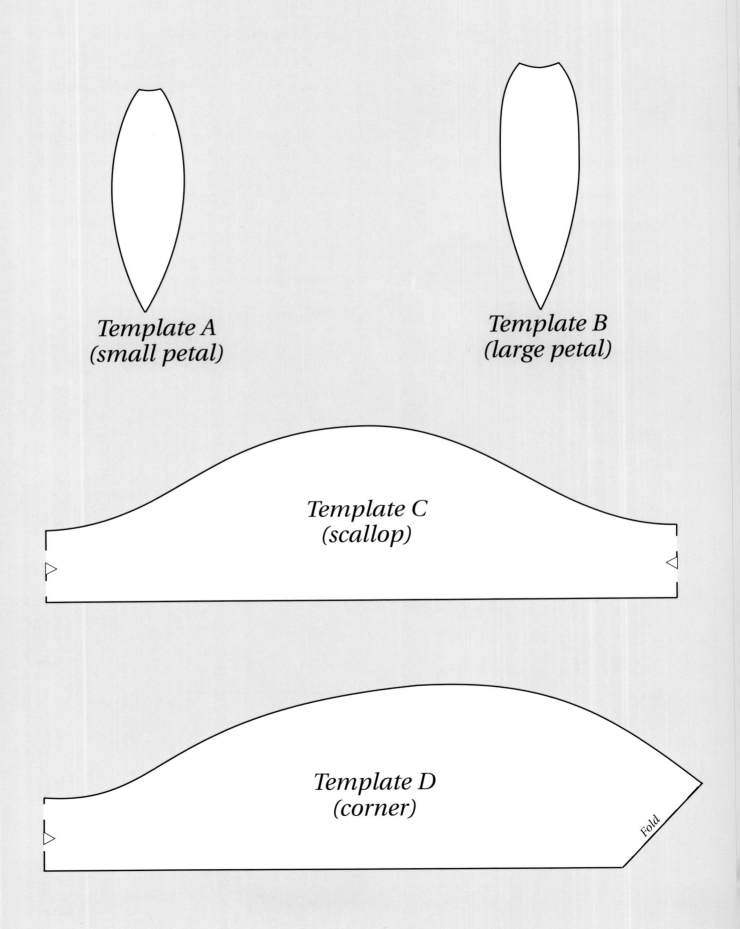

Template A
(small petal)

Template B
(large petal)

Template C
(scallop)

Template D
(corner)

Fold

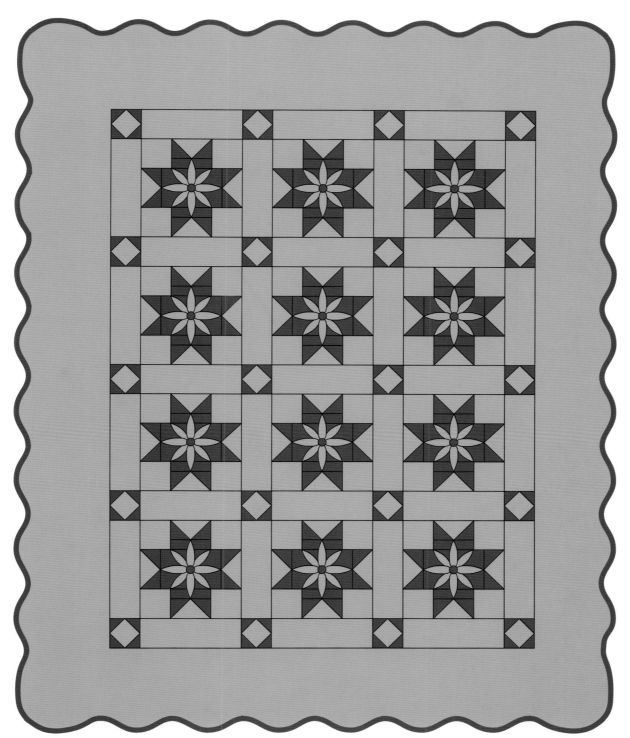

Star Flower Quilt

Delectable Mountains

The Quilts

Indian Trails

Bringing with it bright bands of color,

a handsome strip quilt follows

in the footsteps of the narrow

mocassin-made paths leading quietly

through meadows and mountains.

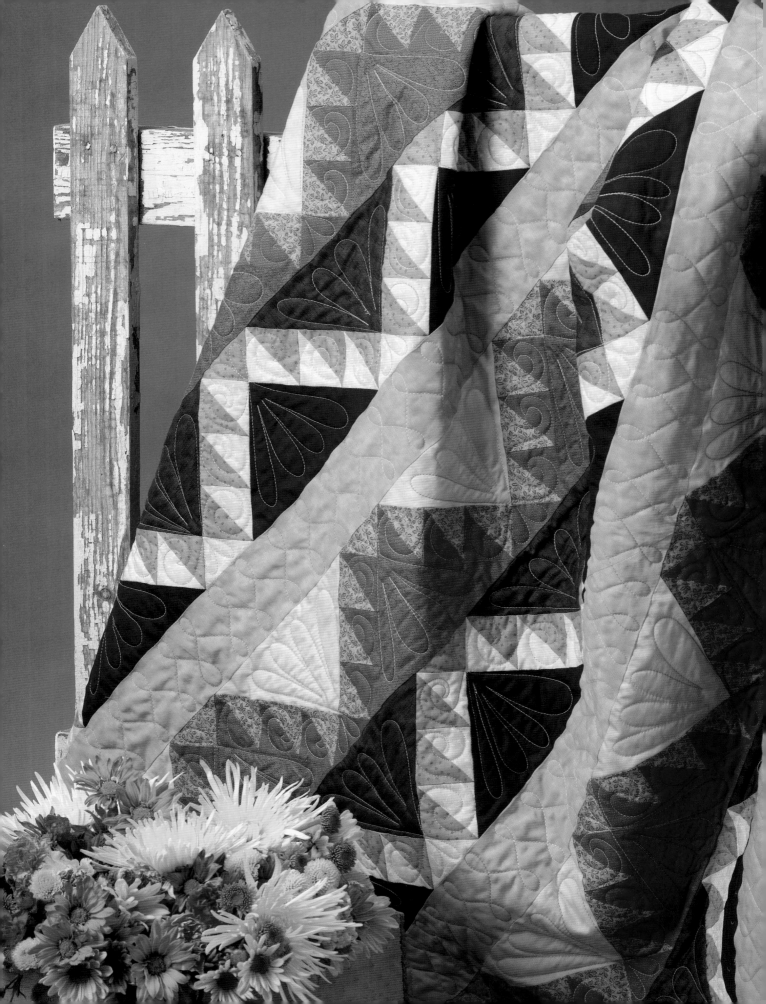

Indian Trails

Approximate finished size of quilt:
51" x 71-1/2"

Materials

1-1/3 yards of purple fabric
for blocks and borders

1 yard of light yellow fabric

1 yard light pink fabric

1 yard dark pink fabric

3/4 yard navy blue fabric

3/4 yard orange fabric

1 yard of bright green fabric

1 yard of dark yellow fabric

1 yard of bright blue fabric for sashing

1/2 yard of lavender fabric for binding

3-1/2 yards of backing fabric
(seamed to fit finished top)

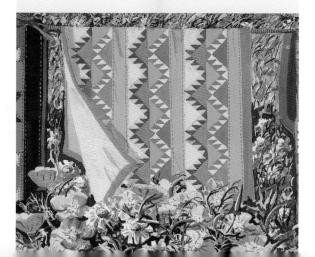

Cotton batting to fit finished top

Indian Trail Strips

Cutting

- From the purple fabric cut:
 6—2-7/8" x 44" strips; from these strips, cut:
 74—2-7/8" squares;
 cut squares in half diagonally once to make
 147—2-7/8" half-square triangles

- From the light yellow fabric cut:
 6—2-7/8" x 44" strips; from these strips, cut:
 72—2-7/8" squares;
 cut squares in half diagonally once to make
 144—2-7/8" half-square triangles
 3—2-1/4" squares; cut in half diagonally once to make
 6—2-1/4" half-square triangles

- From the light pink fabric cut:
 6—2-7/8" x 44" strips; from these strips, cut:
 74—2-7/8" squares;
 cut squares in half diagonally once to make
 144—2-7/8" half-square triangles

- From the dark pink fabric cut:
 6—2-7/8" x 44" strips; from these strips, cut:
 2—2-7/8" squares;
 cut squares in half diagonally once to make
 144—2-7/8" half-square triangles
 3—2-1/4" squares;
 cut squares in half diagonally once to make
 6—2 7/8" half-square triangles

- From the navy blue fabric cut:
 6—11" squares; cut squares in half diagonally twice to make
 24 quarter-square triangles

- From the orange fabric cut:
 6—11" squares; cut squares in half diagonally twice to make
 24 quarter-square triangles

- From the bright green fabric cut:
 5—11" squares; cut squares in half diagonally twice to make
 20 quarter-square triangles
 3—5-1/2" squares, cut in half diagonally once to make
 6—5-1/2" half-square triangles

- From the dark yellow fabric cut:
 5—11" squares; cut in half diagonally twice to make
 20 quarter-square triangles
 3—5-1/2" squares; cut in half diagonally once for
 6—5-1/2" half-square triangles

Assembling the Strips

1. Using a 1/4" seam allowance, sew 126 purple and 126 light yellow 2-7/8" half-square triangles together as shown.

2. Sew the 126 light pink and 126 dark pink 2-7/8" half-square triangles together as shown.

3. Make 21 Strips each of Units A, B, C and D.

Unit A Unit C

Unit B Unit D

4. Add a 2-7/8" half-square triangle to each end of eighteen Units A and C.

Unit A

Unit C

5. Add a 2-1/4" half-square triangle to the end of three Units B and D.

Unit B

Unit D

6. Add a 2-7/8" half-square triangle and a 2-1/4" half-square triangle to each end of three Units A and C.

Unit A

Unit C

Assembling the Block Rows

NOTE: All large triangles have been oversized and will be trimmed later.

1. Make five center blocks each, using the color illustrations below as a guide.

 Make 5

 Make 5

2. Make three right end blocks each, using the color illustrations below as a guide.

 Make 3

 Make 3

3. Make three left end blocks each, using the color illustrations below as a guide.

 Make 3

 Make 3

 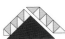

4. Make three rows each by combining the center blocks, right end, and left end blocks.

5. Measure and trim 1/4" from the points of rows.

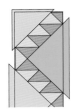 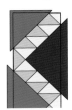

Adding the Sashing and Borders

Cutting

• From the bright blue fabric for sashing cut:
 8—3-1/2" x 44" strips

• From the purple fabric for borders cut:
 4—3" x 44" strips

1. Seam the strips as needed to make four bright blue and two purple 79-1/2" border strips.

2. Sew block rows with bright blue vertical sashing, as shown.

3. Sew purple border to sides of quilt top.

Finishing the Quilt

1. Layer quilt top with batting and backing. Quilt as desired.

2. Refer to General Instructions to bind quilt with lavender background fabric.

Indian Trails Quilt

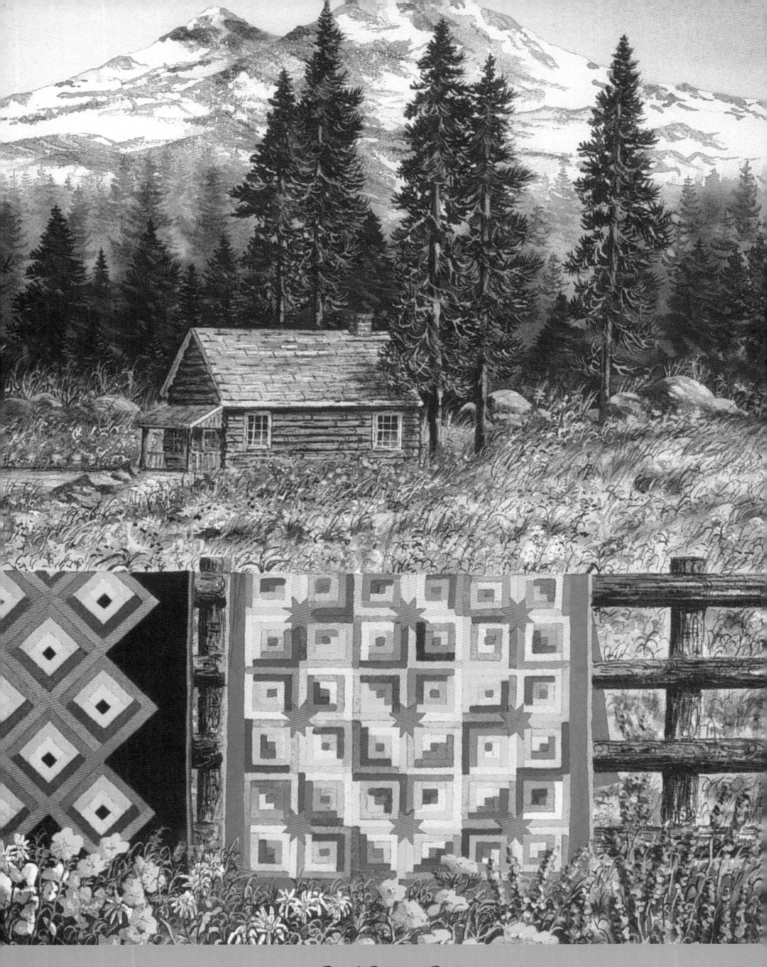

Log Cabin Quilts

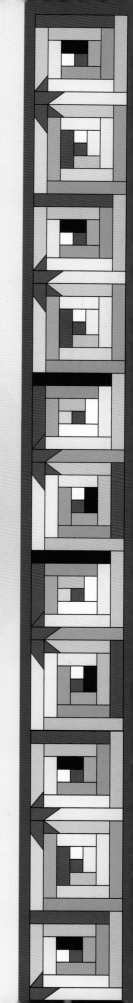

Log Cabin Comfort

A sprinkling of stars and

block center squares in shades

of red radiate warmth and

comfort on a log cabin quilt

nestled in a field of flowers and

surrounded by a forest of pines.

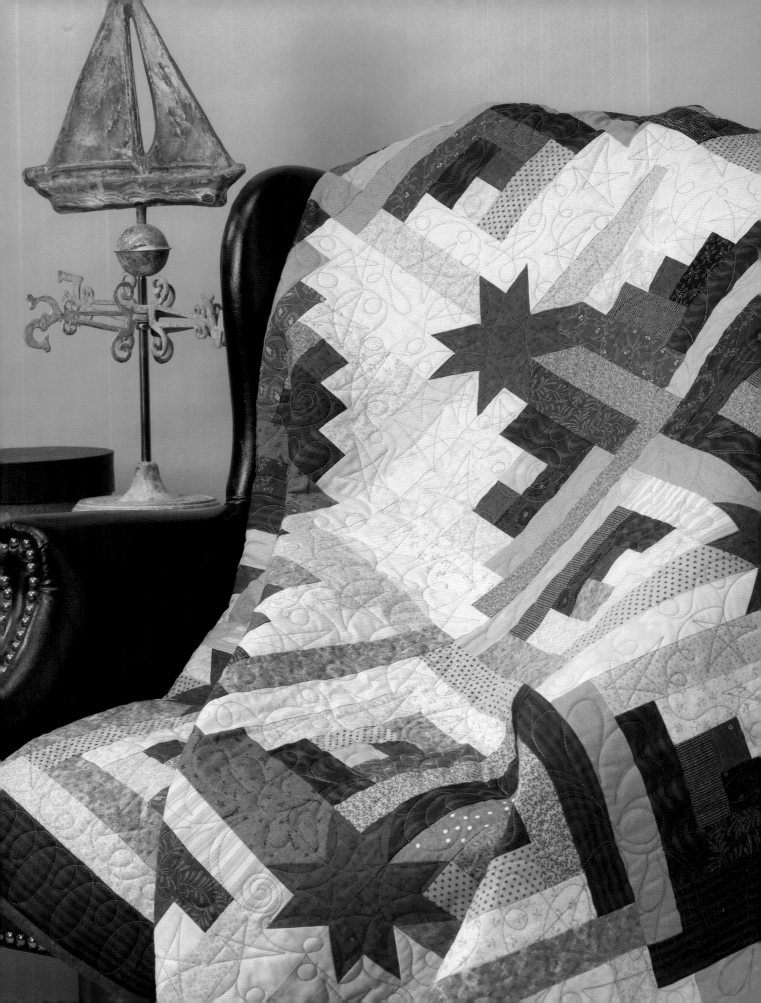

Log Cabin Comfort

Approximate finished size: 69" x 90"

Materials

The yardage for the yellow and blue logs is total yardage needed. Use scraps or purchase many different shades of yellow and blue.

2-1/2 yards of assorted yellow fabrics

2-1/2 yards of assorted blue fabrics

1-1/2 yards of red fabric
for stars and binding

1 yard of blue fabric for border

6 yards of backing fabric
(seamed to fit finished top)

Cotton batting to fit finished top

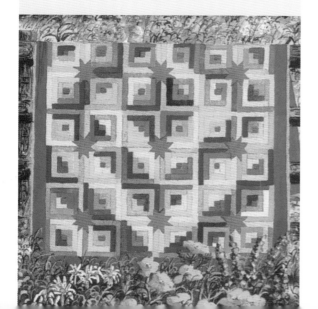

Log Cabin Block

Center Block finished size: 10-1/2" x 10-1/2"

Make 20 Blue Blocks

Make 28 Yellow Blocks

Cutting

- From the red fabric cut:
 3—2" x 44" strips
 48—2" squares for piece A
 48—2" x 3-1/2" rectangles for piece B

- From the yellow fabric cut:
 2—2" x 44" strips
 40—2" x 3-1/2" rectangles for pieces #4 & #5
 40—2" x 6-1/2" rectangles for pieces #6 & #7
 56—2" x 8" rectangles for pieces #8 & #9
 68—2" x 9-1/2" rectangles for pieces #10, #11, & #12

- From the blue fabric cut:
 1—2" x 44" strip
 56—2" x 3-1/2" rectangles for pieces #4 & #5
 56—2" x 6-1/2" rectangles for pieces #6 & #7
 40—2" x 8" rectangles for pieces #8 & #9
 70—2" x 9-1/2" rectangles for pieces #10, #11, & #12

Assembling the Log Cabin Block

1. Draw a diagonal line from corner to corner on wrong side of each of the red 2" squares.

2. Randomly choose 20—blue #9 and 28—yellow #9 pieces. Right sides together, place 2" red squares on the right end of piece #9 rectangles. Stitch on the drawn line. Trim seam allowances to 1/4". Press. Unit #9 should measure 2" x 3-1/2".

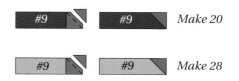

3. Randomly choose 20—blue #12 and 28—yellow #12 pieces. Right sides together, place 2" x 3-1/2" red B rectangle on the right end of piece #12. Draw a diagonal line from corner to corner. Stitch on the drawn line. Trim seam allowances to 1/4". Press. Unit 12 should measure 2" x 11".

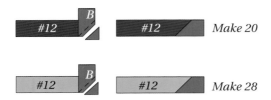

4. For the yellow Center Units, using 1/4" seam allowances sew the two red 2" x 44" strips and two yellow 2" x 44" strips together. Make two strip sets. Cut into 28—2" yellow Center Units.

5. For the blue Center Units, using 1/4" seam allowances sew one red 2" x 44" strip and one blue 2" x 44" strip together. Cut into 20—2" blue Center Units.

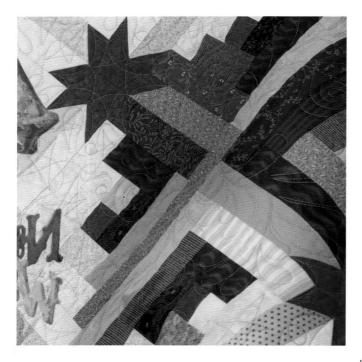

6. Following the number sequence and beginning with the a yellow or blue Center Unit use the following illustrations to assemble:

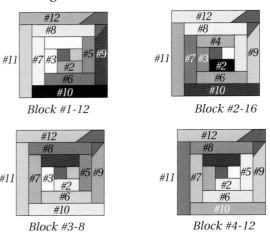

Block #1-12 Block #2-16

Block #3-8 Block #4-12

7. Blocks should measure 11" to each unfinished edge.

Assembling the Quilt Top

1. Lay out the blocks into rows and sew rows together.

Adding the Borders

- From the blue fabric cut:
 8—3-1/2" x 44" strips

1. Seam the strips as needed to make two 84-1/2" border strips. Sew to sides of the quilt top.

2. Seam the strips as needed to make two 69-1/2" border strips. Sew to top and bottom of the quilt top.

Finishing the Quilt

1. Layer quilt top with batting and backing. Quilt as desired.

2. Refer to General Instructions to bind quilt with red fabric.

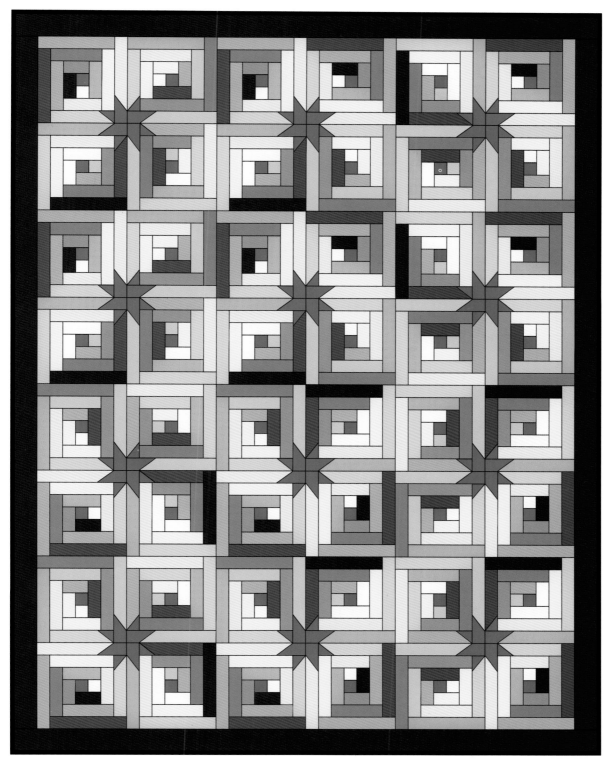

Log Cabin Comfort Quilt

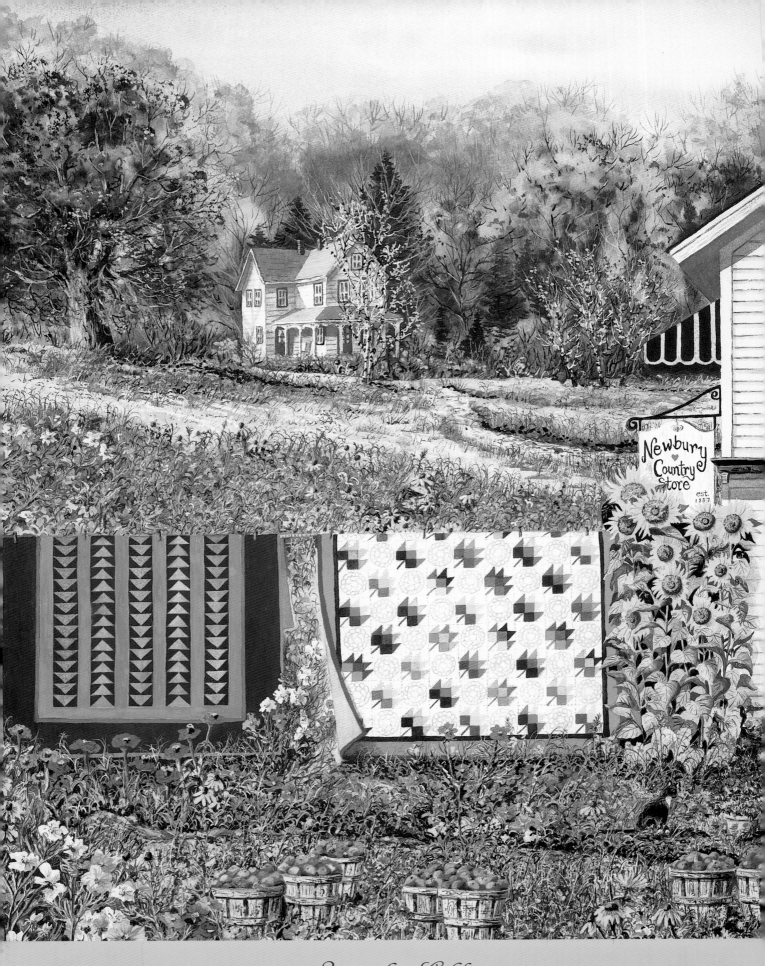

September Gold

The Quilts

Amish Flight

A traditional Flying Geese block

pattern pieced in the subdued

shades of solid color preferred by

the Amish quilter, provides high-flying

contrast to the hazy September sky.

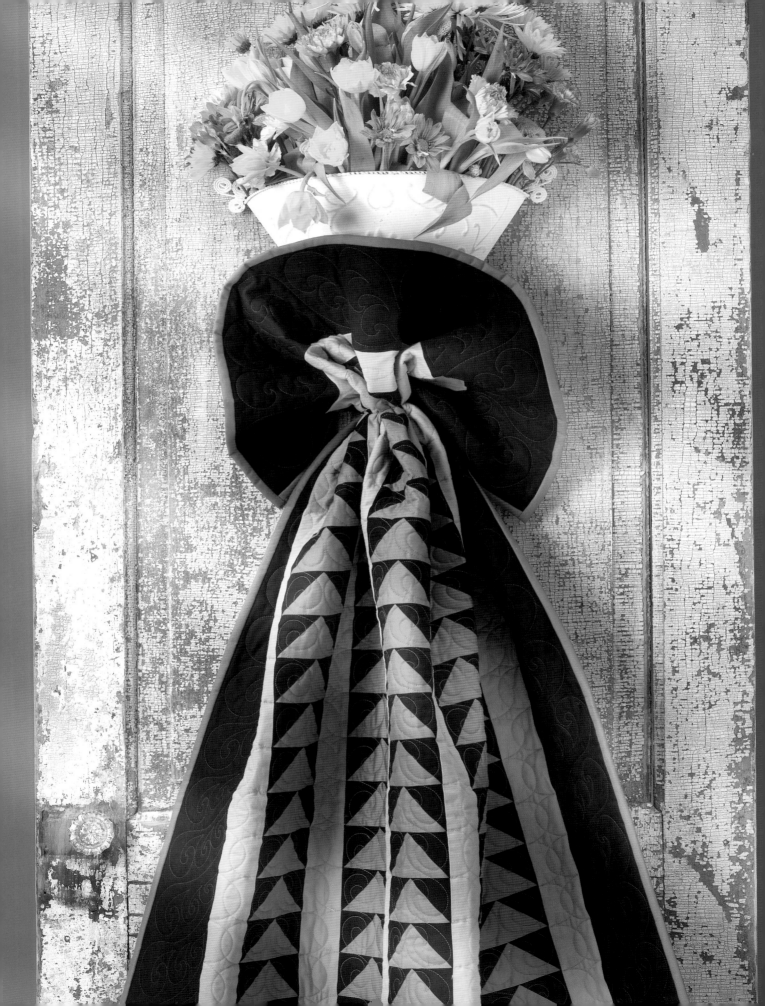

Amish Flight

Approximate finished size: 42" x 56"

Materials:

2 yards of black fabric
for blocks and borders

1/2 yard of pink fabric
for Flying Geese

1-1/8 yards of blue fabric
for Flying Geese and binding

3/4 yard of lavender fabric
for sashing

2-3/4 yards of backing fabric
(seamed to fit finished top)

Cotton batting to fit finished top

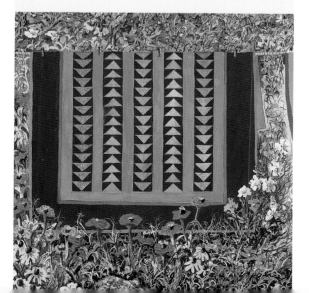

Flying Geese Block

Block finished size: 2" x 4"

Make 105 Blocks

Cutting

- From the black fabric cut:
 14—2-1/2" x 44" strips; from these strips, cut:
 210—2-1/2" squares

- From the pink fabric cut:
 3—4-1/2" x 44" strips; from these strips, cut:
 42—2-1/2" x 4 1/2" rectangles

- From the blue fabric cut:
 4—4-1/2" x 44" strips; from these strips, cut:
 63—2-1/2" x 4-1/2" rectangles

Assembling the Blocks

1. Draw a diagonal line from corner to corner on the wrong side of each of the 210—2-1/2" black squares.

2. Right sides together, place one black square on one corner of each of the 42—pink and 63—blue rectangles. Stitch on the drawn line. Trim seam allowance to 1/4". Press. Repeat for other side. Make 42—pink Flying Geese and 63—blue Flying Geese. Blocks should measure 2-1/2" x 4-1/2".

3. Using 1/4" seam allowances, sew three rows of 21—blue Flying Geese and two rows of 21—pink Flying Geese. Press seams as shown.

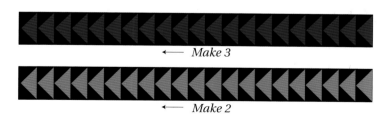

← Make 3

← Make 2

Adding the Sashing

• From the lavender fabric cut:
 6—2-1/2" x 42-1/2" strips
 2—2-1/2" x 32-1/2" strips

1. Lay out 42-1/2" sashing rows as shown in the illustration below. Sew strips to each side and between each row. Press seams as shown.

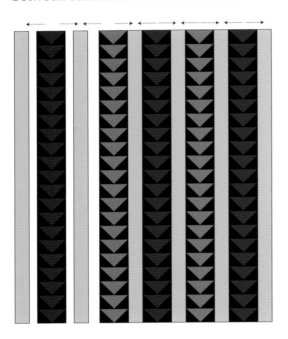

2. Sew 32-1/2" strips to the top and bottom of quilt top.

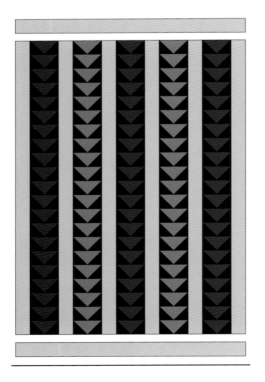

Adding the Borders

• From the black fabric cut:
 6—5-1/2" x 44" strips

1. Seam the strips as needed to make two—46-1/2" border strips. Sew strips to the sides of quilt top.

2. Seam the strips as needed to make two—42-1/2" lengths. Sew to the top and bottom of quilt top.

Finishing the Quilt

1. Layer quilt top with batting and backing. Quilt as desired.

2. Refer to General Instructions to bind quilt with light blue fabric.

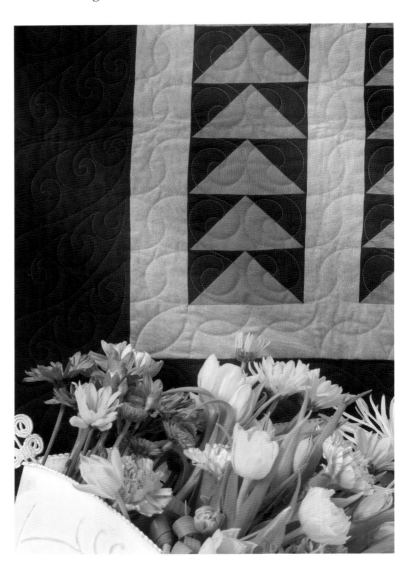

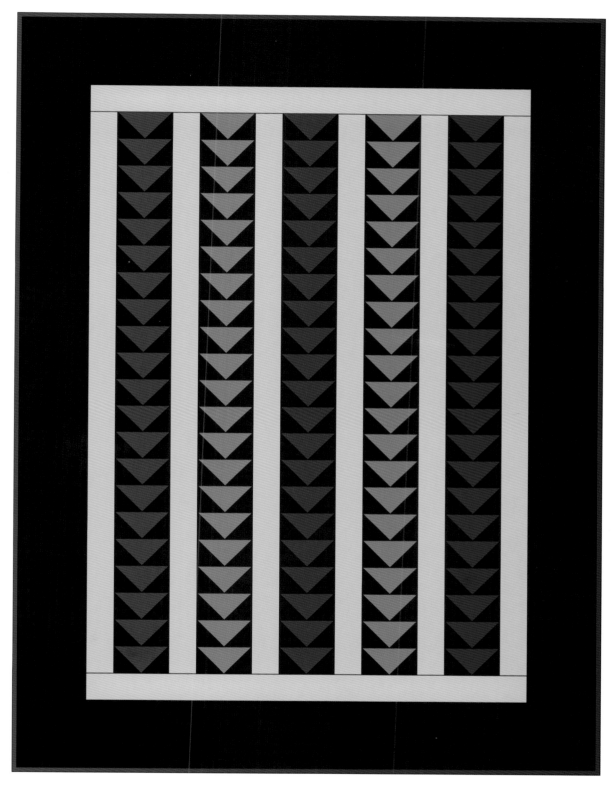

Amish Flight Quilt

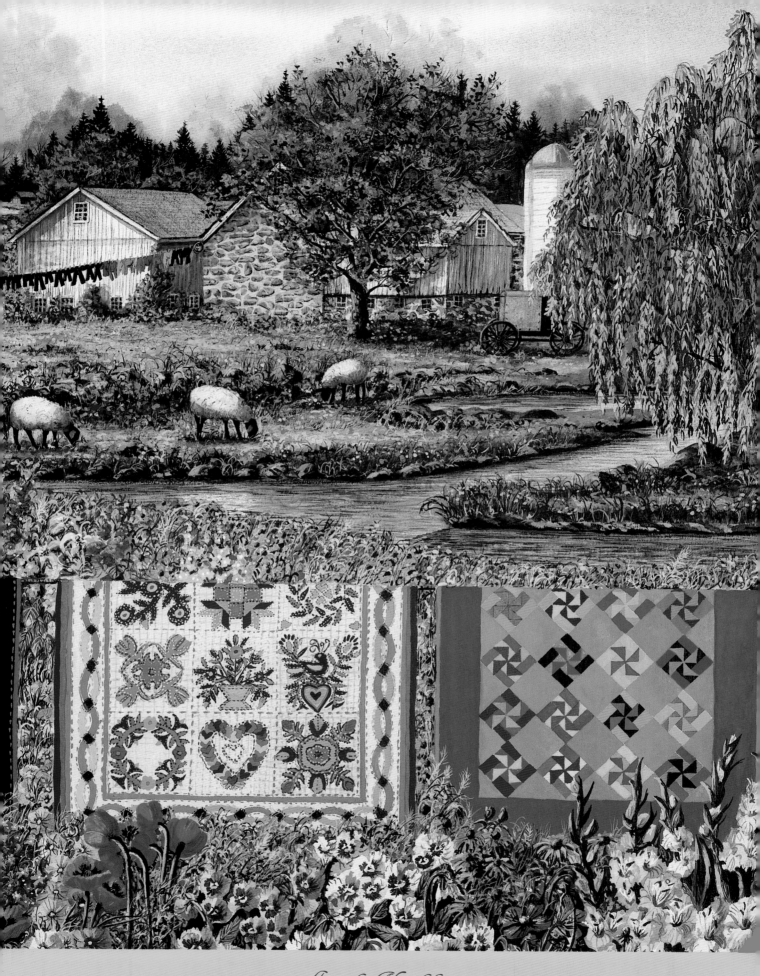

Amish Neighbors

The Quilts

Patchwork Pinwheels

A pleasing patchwork of spinning

pinwheels soaks up the summer

sunshine—shared with a flock of

grazing sheep and freshly

laundered clothes drying on the line.

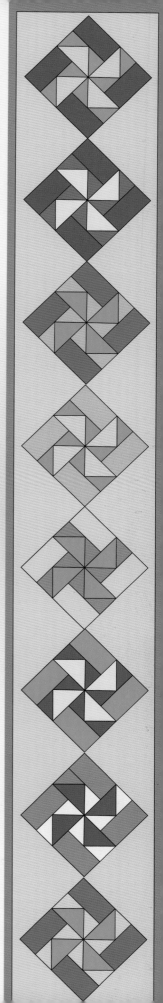

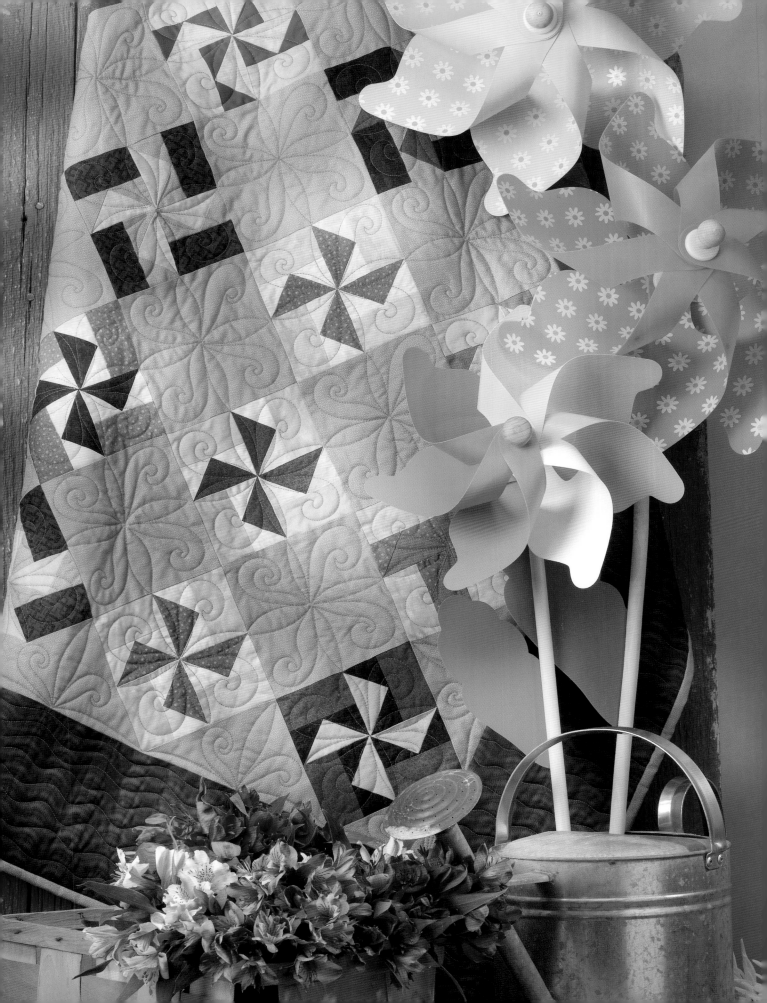

Patchwork Pinwheels

Approximate finished size: 47" x 64"

Materials

1/3 yard each of 8 assorted colors of fabric for pinwheel blocks

1-5/8 yards of light blue fabric for background and binding

1-1/2 yards of dark blue fabric for borders

4 yards of backing fabric (seamed to fit)

Cotton batting to fit finished top

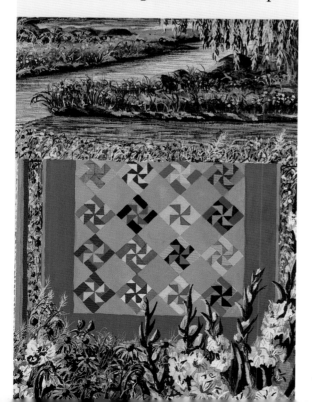

Pinwheel Block

Block finished size: 6" x 6"

Make 24 Blocks

Cutting

- From each of the 8 assorted 1/3 yard pieces cut:
 24—2" x 3 1/2" rectangles for pinwheels
 24—2" squares

Assembling the Pinwheel Block

1. Mix and match the assorted color fabrics into 24 blocks. For each block choose 3 colors:
 - color #1: 4—2" x 3 1/2" rectangles for pinwheel
 - color #2: 8—2" squares for pinwheel
 - color #3: 4—2" x 3 1/2" rectangles

2. Sew one block at a time. Draw a diagonal line from corner to corner on wrong side of each of the 8—2" squares (color #2).

3. Right sides together, place a 2" square on one end of a 2" x 3-1/2" rectangle (color #1). Stitch on drawn line. Trim seam allowance to 1/4". Press. Repeat for other side. Make 96 (4 for each Pinwheel Block).

Make 4 Unit 1

4. Using 1/4" seam allowance, sew a color #3 rectangle to Unit 1, as shown.

5. Assemble each Pinwheel Block as shown. Block should measure 6-1/2" square to each unfinished square.

 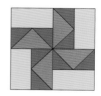

Assembling the Quilt Top

Cutting

- From the light blue fabric cut:

 15—6 1/2" squares

 2—5 1/2" squares cut in half diagonally once to make corner triangles

 4—9 3/4" squares cut in half diagonally twice to make setting triangles

Assembling Rows

1. Using setting triangles and Pinwheel Blocks assemble rows as shown. Press seams in opposite directions.

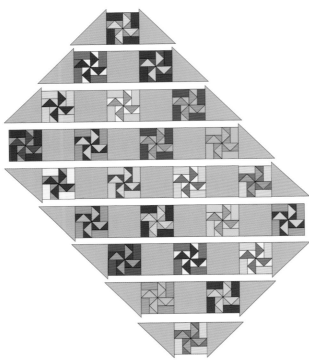

2. Sew rows together. Sew corner triangles to the quilt top.

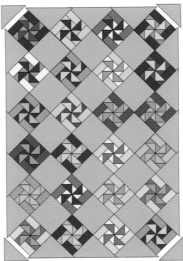

3. Measure 1/4" from points and trim, as shown.

Adding the Borders

- From the dark blue fabric cut:

 7—7" x 44" strips

1. Seam the strips as needed to make two 51-1/2" border strips. Sew strips to sides of the quilt top.

2. Seam the strips as needed to make two 47-1/2" border strips. Sew to top and bottom of the quilt top.

Finishing the Quilt

1. Layer quilt top with batting and backing. Quilt as desired.

2. Refer to General Instructions to bind quilt with light blue fabric.

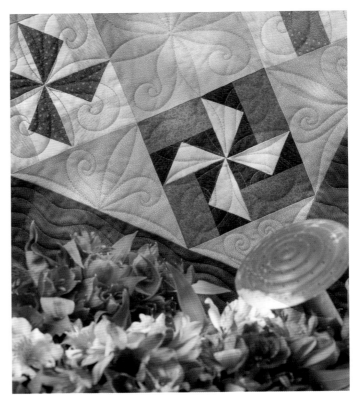

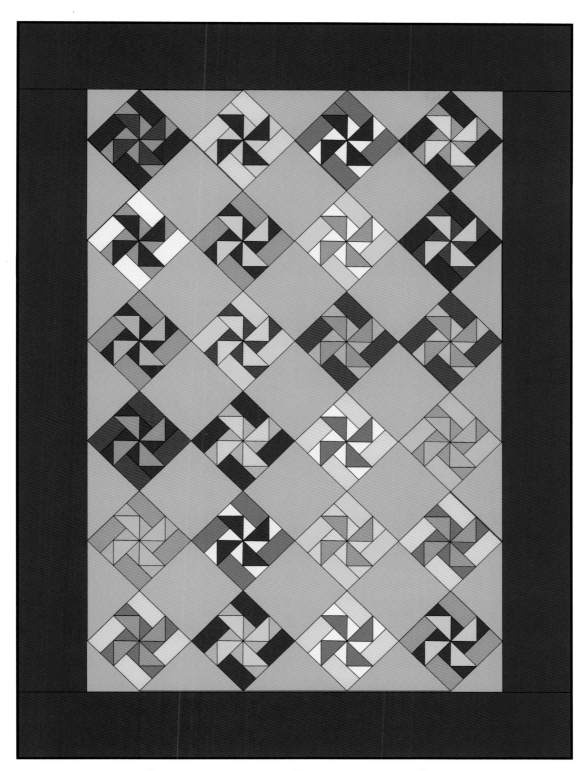

Patchwork Pinwheels Quilt

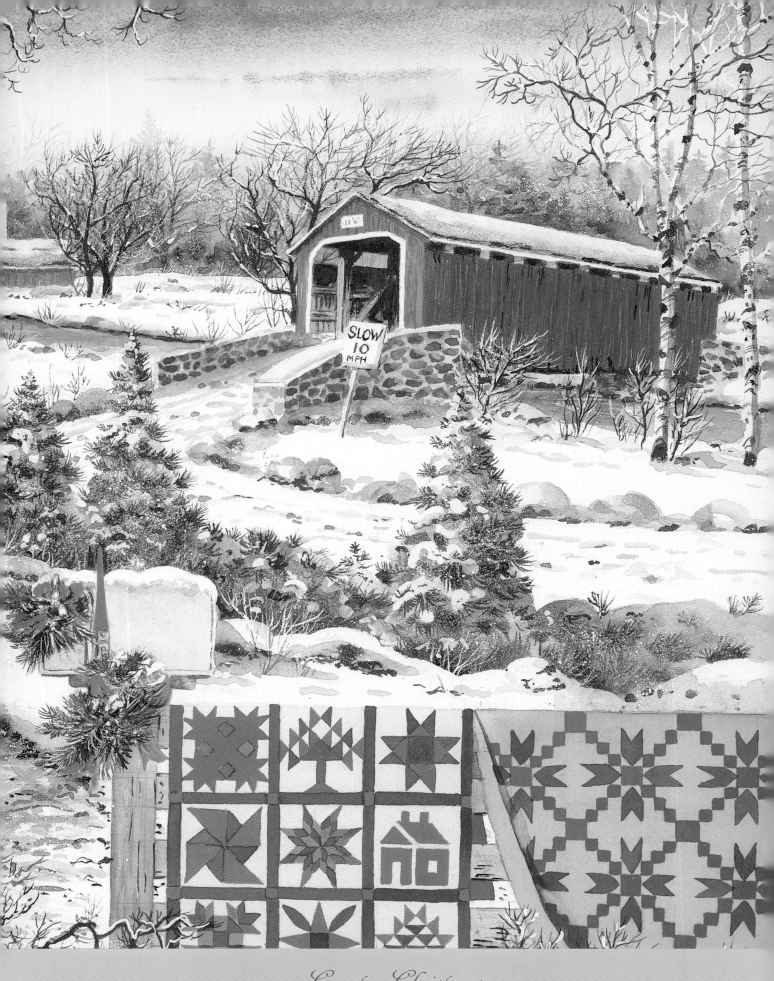

Country Christmas

The Quilts

Holiday Cheer

Originally created to offer warmth

and comfort from the cold, classic

country quilts in festive green and red

complement the barn-red boards of a

covered bridge built long ago to

be a sturdy shelter from the storm.

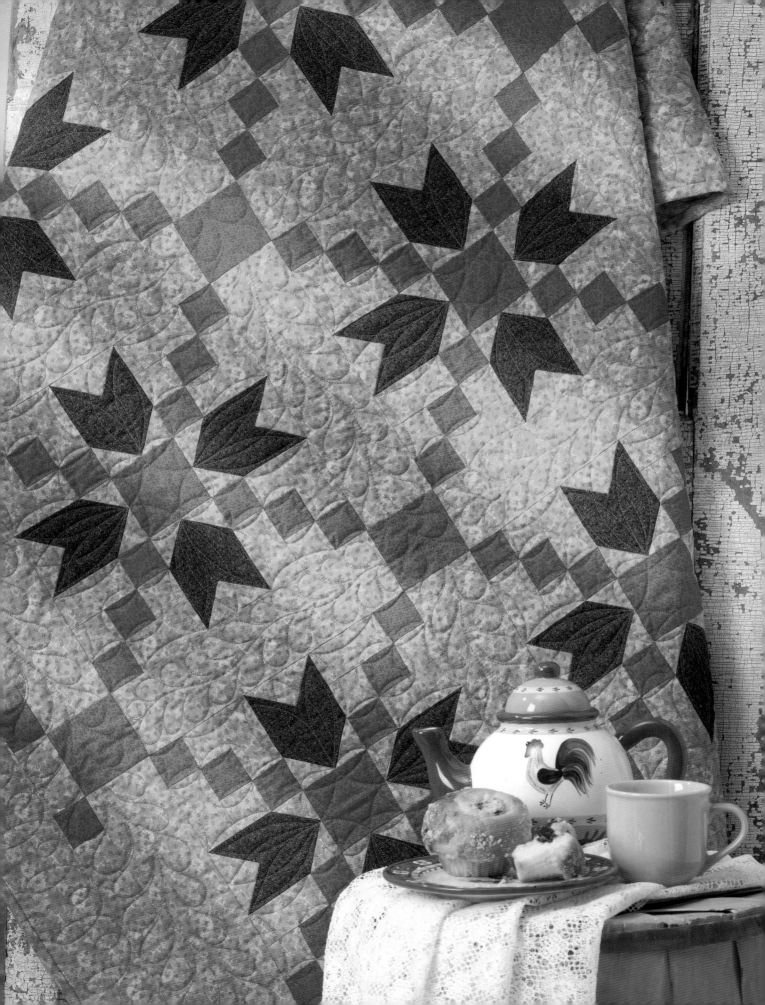

Holiday Cheer

Approximate finished size: 72" x 87"

Materials

1-1/2 yards of green fabric for blocks

1-1/2 yards of red fabric for blocks and corner stones

4 yards of gold fabric for background, sashing, borders and binding

6 yards of backing fabric (seamed to fit)

Cotton batting to fit finished top

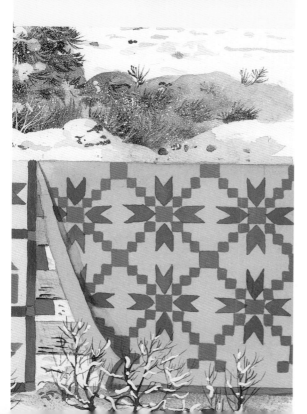

Stepping Stone Block

Block finished size: 12" x 12"

Make 20 Blocks

Cutting

- From the red fabric cut:
 13—2" x 44" strips for strip piecing
 2—3-1/2" x 44" strips; cut these strips to make
 20—3-1/2" squares

- From the green fabric cut:
 8—2" x 44" strips; cut these strips to make
 160—2" squares
 7—3-1/2" x 44" strips; cut these strips to make
 160—3-1/2" squares

- From the gold fabric cut:
 11—2" x 44" strips for strip piecing
 8—2" x 44" strips; cut into
 160—2" squares
 4—3-1/2" x 44" strips; cut these strips to make
 80—2" x 3-1/2" rectangles

Assembling the Stepping Stone Block

1. Make 8 strip sets using the red 2" x 44" strips and the gold 2" x 44" strips. Cut into 160—2" units.

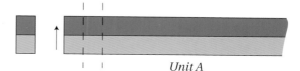

Unit A

2. Make 5 strip sets using red and gold 2" x 44" strips. Cut into 80—2" units.

Unit B

3. Using Units A and B, make 80 Unit AB. Units should measure 5" to unfinished edge.

Unit AB

4. Draw a diagonal line from corner to corner on wrong side of each of the 160 green and 160 gold 2" squares.

5. Right sides together, place a 2" green square on one end of a gold 2" x 3-1/2" rectangle. Stitch on the drawn line. Trim seam allowance to 1/4". Press. Repeat for the other side. Make 80 Unit C rectangles. Unit C should measure 2" x 3-1/2" to each unfinished edges.

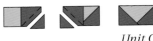

Unit C

6. Right sides together, place a 2" gold square on the green 3-1/2" square. Stitch on the drawn line. Trim seam allowance to 1/4". Press. Repeat for other side. Make 80 Unit D squares. Unit D should now measure 3-1/2" to each unfinished edge.

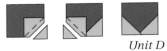

Unit D

7. Using 1/4" seam allowance sew Units C and D together to make 80 Units CD. Unit CD should measure 3-1/2" x 5" to each unfinished edge.

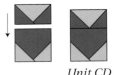

Unit CD

8. Sew one Unit CD to each end of a 3-1/2" red square.

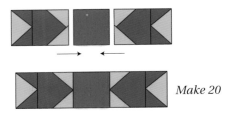

Make 20

9. Sew one Unit AB to each side of 20 Units CD.

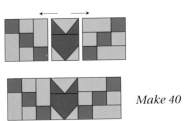

Make 40

10. Following layout, sew blocks together. Each block should now measure 12-1/2" square.

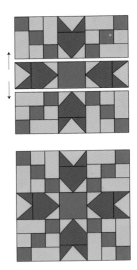

Adding the Sashing

Cutting

- From the red sashing fabric cut:
 4—2" x 22" strips
 2—2" x 6" rectangles
 3—3-1/2" x 44" strips

- From the gold sashing fabric cut:
 1—2" x 44" strip
 2—9-1/2" x 22" strips
 2—3-1/2" x 22" strips
 1—3-1/2" x 6" rectangle
 3—12-1/2" x 44" strips;
 from these strips cut 2 to make
 25—3-1/2" x 12-1/2" rectangles
 6—2" x 3-1/2" rectangles

Assembling the Sashing

1. Make the strip sets using quantities and measurements given for Units 1–5 in the Sashing Unit steps. Press in the direction indicated by the arrows on the illustrations.

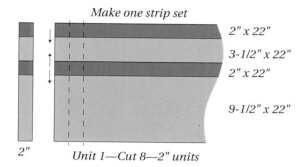

Make one strip set

2" x 22"

3-1/2" x 22"

2" x 22"

9-1/2" x 22"

2" Unit 1—Cut 8—2" units

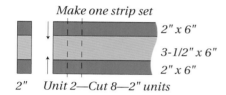

Make one strip set

2" x 6"

3-1/2" x 6"

2" x 6"

2" Unit 2—Cut 8—2" units

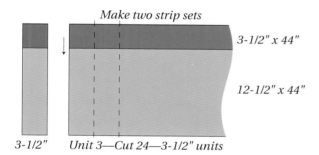

Make two strip sets

3-1/2" x 44"

12-1/2" x 44"

3-1/2" Unit 3—Cut 24—3-1/2" units

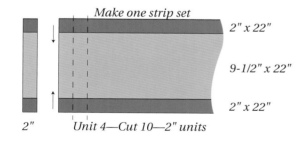

Make one strip set

2" x 22"

9-1/2" x 22"

2" x 22"

2" Unit 4—Cut 10—2" units

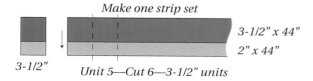

Make one strip set

3-1/2" x 44"

2" x 44"

3-1/2" Unit 5—Cut 6—3-1/2" units

Sashing Unit

1. Sew four Unit 3 pieces together. Sew a gold 2" x 3-1/2" rectangle to the left end and one Unit 5 to the right end. Make six Sashing Units. Press in direction indicated by arrows.

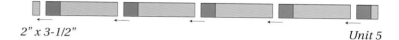

2" x 3-1/2"

Unit 5

2. Sew four Unit 1 pieces together and one Unit 2 to the right end. Make two for top and bottom inner borders. Press in direction indicated by arrows.

Unit 2

3. Sew two Unit 4 and five 3-1/2" x 12-1/2" rectangles together with four of the blocks to make five block rows. Press.

Assembling the Quilt Center

1. Sew the Block Rows together. With the sashing rows, sew the top and bottom borders to quilt top, as shown. Press seams in one direction.

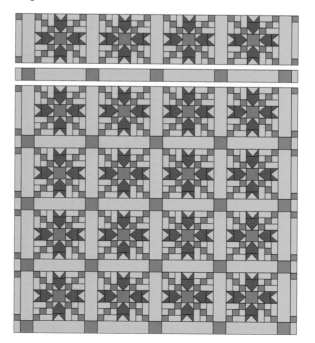

Adding Outside Borders

• From the gold fabric cut
 8—3-1/2" x 44" strips

1. Seam the strips as needed to make two
 81-1/2" border strips. Sew to sides of the
 quilt top.

2. Seam the strips as needed to make two
 72-1/2" border strips. Sew to top and bottom
 of the quilt top.

Finishing the Quilt

1. Layer quilt top with batting and backing.
 Quilt as desired.

2. Refer to General Instructions to bind quilt with
 gold fabric.

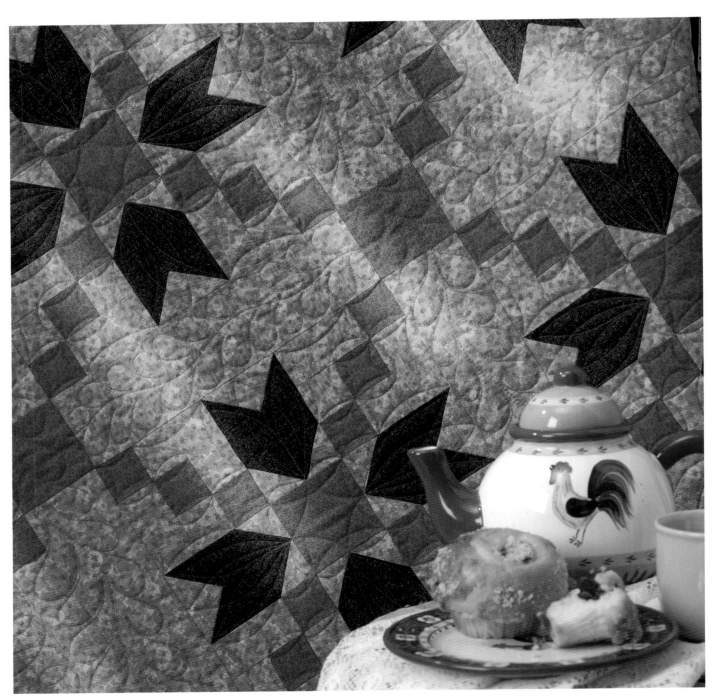

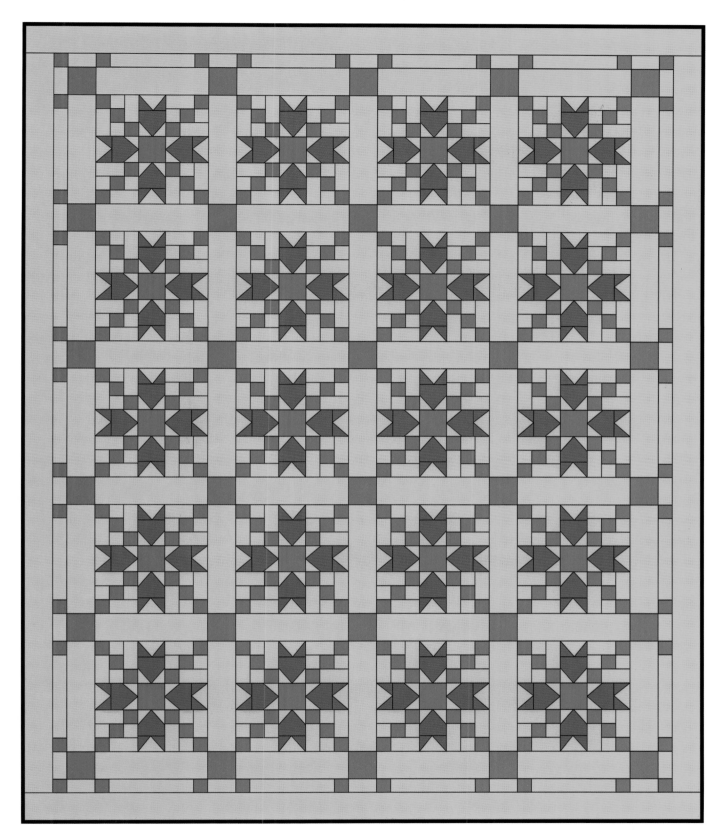

Holiday Cheer Quilt

Delectable Mountains

The Quilts

Mountain Majesty

A masterful tribute to nature's

contrasts, the bright but bold

Tree of Life block mirrors the beauty

of the birds, butterflies, deer,

and delicate wildflowers set against a

backdrop of snow-capped mountains.

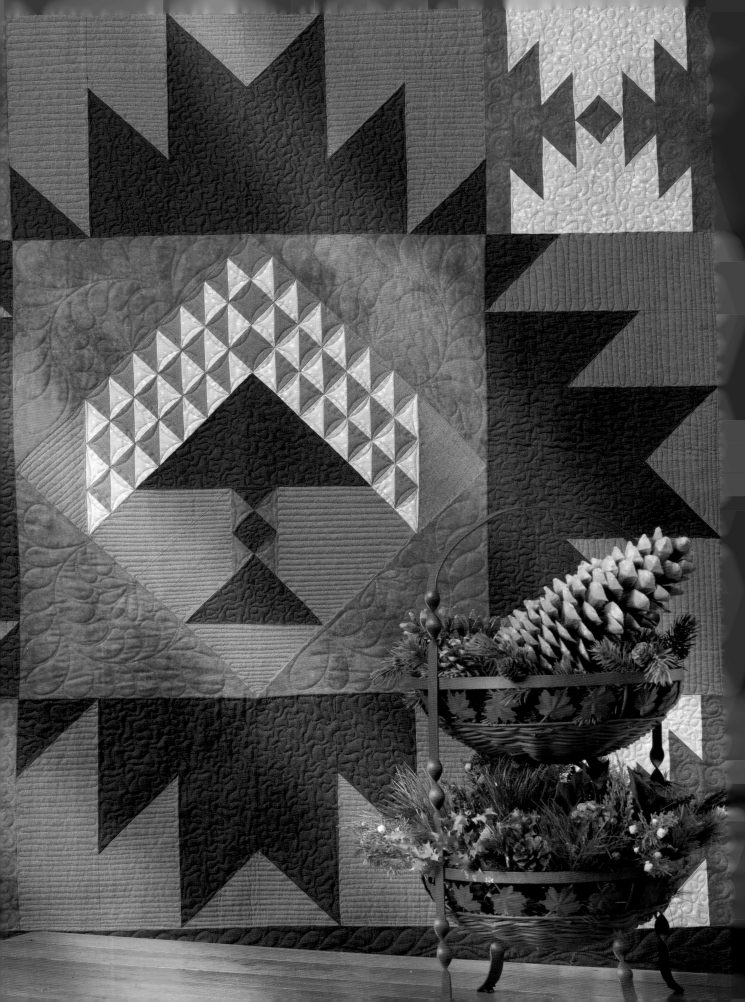

Approximate finished size: 64" x 64"

Materials

1-1/2 yards of black fabric
for Tree Block and borders

❖

2-1/2 yards of dark green fabric
for Tree Block and borders

❖

1 yard of light green fabric
for Tree Block and borders

❖

1-3/4 yards of red fabric
for Tree Block, borders and binding

❖

4 yards of backing fabric
(seamed to fit finished top)

❖

Cotton batting to fit finished top

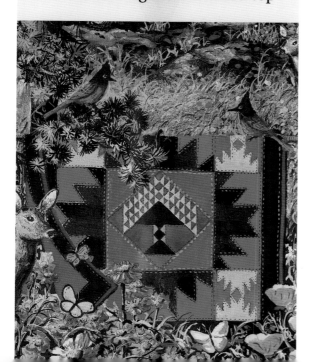

Blocks

Center Block finished size: 20" x 20"

Cutting

- From the black fabric cut:
 1—2-1/2" square
 1—2-7/8" square; cut in half diagonally once to make
 2—2-7/8" half-square triangles
 1—10-7/8" square; cut in half diagonally once to make
 2—10-7/8" half-square triangles
 1—6-7/8" square; cut in half diagonally once to make
 2—6-7/8" half-square triangles

- From the light green fabric cut:
 21—2-7/8" squares; cut in half diagonally once to make
 42—2-7/8" half-square triangles

- From the dark green fabric cut:
 3—2-1/2" squares
 2—6-7/8" squares; cut in half diagonally once to make
 4—6-7/8" half-square triangles
 2—2-1/2" x 6-1/2" rectangles
 2—2-1/2" x 8-1/2" rectangles
 2—4-1/2" x 8-1/2" rectangles

- From the red fabric cut:
 4—2-1/2" squares
 2—15" squares; cut in half diagonally once to make
 4 half-square triangles

Center Tree Block

Piecing the Tree Top

1. Using 1/4" seam allowance, sew 36—2-7/8"
 light green and 36—2-7/8" dark green half-square
 triangles into triangle squares.

Make 36

2. Make one Unit A side of the Tree Top and one Unit B, using triangle squares, 2-1/2" dark green squares, 6-7/8" dark green half-square triangles and the remaining 2-7/8" light green half-square triangles.

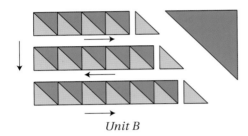

Unit A

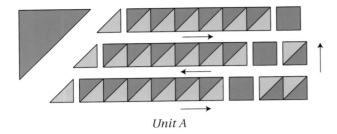

Unit B

Piecing the Tree Trunk

1. Using 1/4" seam allowance, sew one 6-7/8" dark green and one 6-7/8" black half square triangle together to make one triangle square.

Unit 1

2. Draw a diagonal line from corner to corner on the wrong side of each of the four red 2-1/2" squares.

3. Right sides together, position one red square on the right end of one dark green 2-1/2" x 6-1/2" rectangle. Sew on the drawn line. Trim seam allowance to 1/4". Press.

Unit 2

4. Right sides together, position one red square on the left end of one dark green 2-1/2" x 6-1/2" rectangle. Sew on the drawn line. Trim seam allowance to 1/4". Press. Sew one black 2-1/2" square to the left end of the rectangle.

Unit 3

5. Right sides together, position one red square on the right end of one dark green 2-1/2" x 8-1/2" rectangle. Sew on the drawn line. Trim seam allowance to 1/4". Press.

Unit 4

6. Right sides together, position one red square on the left end of one dark green 2-1/2" x 8-1/2" rectangle. Sew on the drawn line. Trim seam allowance to 1/4". Press. Sew one black 2-7/8" square triangle to the left end.

Unit 5

7. For Units 6 and 7: Measure in 4-1/2" from each end of the 4-1/2" x 8-1/2" rectangles. Cut diagonally from each corner to make a right and a left piece.

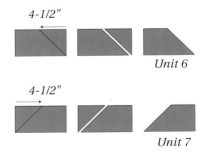

4-1/2"

Unit 6

4-1/2"

Unit 7

8. Following layout, sew Units 1–8 together in the order shown.

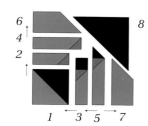

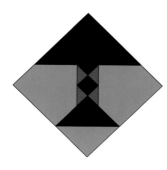

9. Sew Unit 2B to the right side of the Tree Trunk Unit. Sew Unit 2A to the left side of the Tree Trunk Unit.

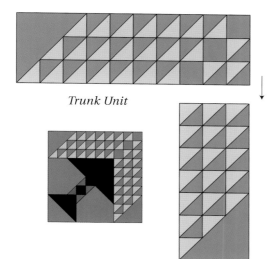

Trunk Unit

10. Sew the red 15" half-square triangles to each corner of the Tree Unit.

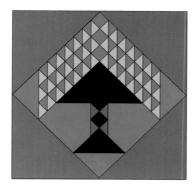

Assembling the Corner Blocks

Cutting

- From the light green fabric cut:
 8—2-3/8" squares; cut in half once
 diagonally to make
 16—2-3/8" half-square triangles
 16—2-1/2" x 4-1/2" rectangles
 16—2-1/2" x 6-1/2" rectangles
 16—3-1/2" x 6-1/2" rectangles

- From the red fabric cut:
 4—2-5/8" squares
 8—2-1/2" x 6-1/2" rectangles
 8—2-1/2" x 10-1/2" rectangles
 8—2" x 14-1/2" rectangles

1. Using a 1/4" seam allowance, sew two 2-3/8" half-square triangles to the opposite sides of a 2-5/8" red square. Repeat for the other two sides. Make four Corner Square Units for the center.

Make 4

2. Sew one light green 3-1/2" x 6-1/2" rectangle to each end the Corner Square Unit for the center.

6" x 3-1/2" 6" x 3-1/2"

Make 4

3. Right sides together, position a 2-1/2" x 4-1/2" light green rectangle on each end of the 2-1/2" x 10-1/2" red rectangle. Draw a diagonal line. Stitch on the drawn line. Trim seam allowance to 1/4". Press. Repeat for other side.

2-1/2" x 4-1/2"

2-1/2" x 10-1/2" *Make 8*

Unit C

4. Right sides together, position a 2-1/2" x 6-1/2" light green rectangle on each end of the 2-1/2" x 6-1/2" red rectangle. Draw a diagonal line. Stitch on the drawn line. Trim seam allowance to 1/4". Press. Repeat for other side of rectangle.

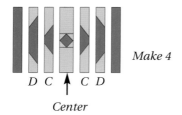

2-1/2" x 6-1/2" *Unit D* *Make 8*

5. Assemble the Outside Corner Blocks using Corner Square Units for the center, Units C and D and the red 2" x 14-1/2" rectangles.

Make 4

D C C D

Center

Assembling the Side Border Blocks

Cutting

- From the black fabric cut:
 8—5-1/4" squares
 8—5-1/4" x 10" rectangles
 8—5-1/4" x 14-1/2" rectangles

- From the dark green fabric cut:
 8—5-1/4" squares
 8—5-1/4" x 10" rectangles
 8—5-1/4" x 14-1/2" rectangles

1. Draw a diagonal line from corner to corner on the wrong side of each of the eight black 5-1/4" squares.

2. Right sides together, position one black square on the left end of one dark green 5-1/4" x 14-1/2" rectangle. Sew on the drawn line. Trim seam allowance to 1/4". Press.

5-1/4" square

5-1/4" x 14-1/2" *Unit J*
 Press to green

3. Right sides together, position one black square on the right end of one dark green 5-1/4" x 14-1/2" rectangle. Sew on the drawn line. Trim seam allowance to 1/4". Press.

5-1/4" square

5-1/4" x 14-1/2" *Unit E*
 Press to black

4. Right sides together, position a 5-1/4" x 10" black rectangle on left end of a 5-1/4" x 9-3/4" dark green rectangle. Draw a diagonal line. Stitch on the drawn line. Trim seam allowance to 1/4". Press. Repeat for other side.

5-1/4" x 10" *Unit F*
 Press to black
5-1/4" x 9-3/4"

5. Right sides together, position a 5-1/4" x 10" black rectangle on right end of a 5-1/4" x 9-3/4" dark green rectangle. Draw a diagonal line. Stitch on the drawn line. Trim seam allowance to 1/4". Press. Repeat for other side.

5-1/4" x 10" *Unit I*

5-1/4" x 9-3/4" → *Press to green*

6. Draw a diagonal line from corner to corner on the wrong side of each of the eight dark green 5-1/4" squares.

7. Right sides together, position one dark green square on the left end of one black 5-1/4" x 14-1/2" rectangle. Sew on the drawn line. Trim seam allowance to 1/4". Press.

5-1/4" x 14-1/2" 5-1/4" square

Unit H
Press to black

8. Right sides together, position one dark green square on the right end of one black 5-1/4" x 14-1/2" rectangle. Sew on the drawn line. Trim seam allowance to 1/4". Press.

5-1/4" x 14-1/2" 5-1/4" square

Unit G
Press to green

9. Using a 1/4" seam allowance, sew Units E–J together.

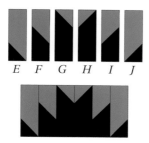

E F G H I J

10. Using 1/4" seam allowance, sew two Side Border Blocks to the sides of the Tree Block.

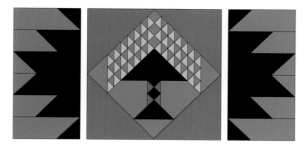

11. Sew a Corner Block to each end of the two Side Border Blocks.

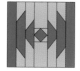

12. Sew the top and bottom of the Tree Block.

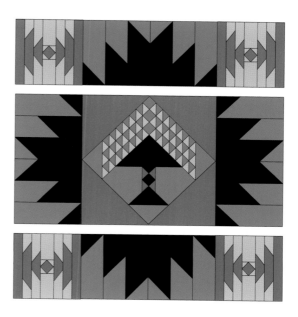

Adding the Borders

• From the black fabric cut:
8—4-1/2" x 44" strips

1. Seam the strips as needed to make two 56-1/2" border strips. Sew to the sides of the quilt top.

2. Seam the strips as needed to make two 64-1/2" border strips. Sew to the top and bottom of the quilt top.

Finishing the Quilt

1. Layer quilt top with batting and backing. Quilt as desired.

2. Refer to General Instructions to bind quilt with red fabric.

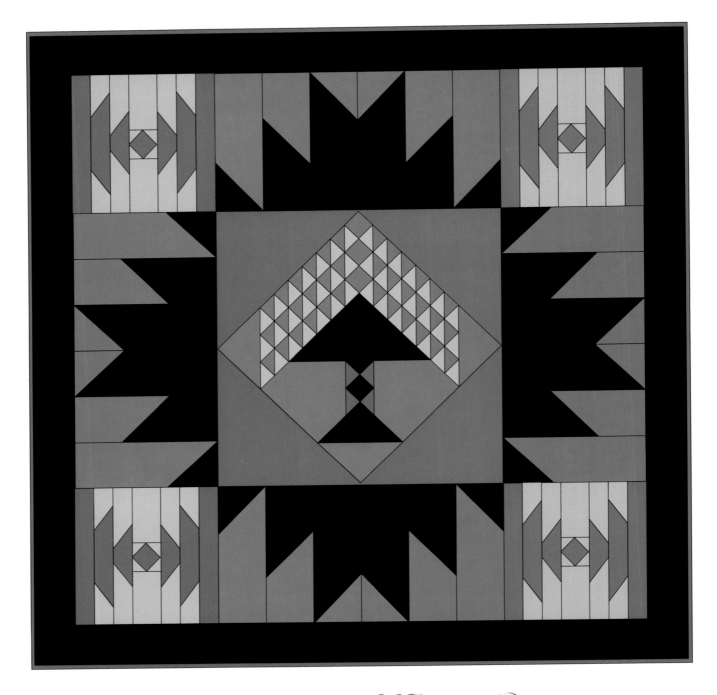

Mountain Majesty Quilt

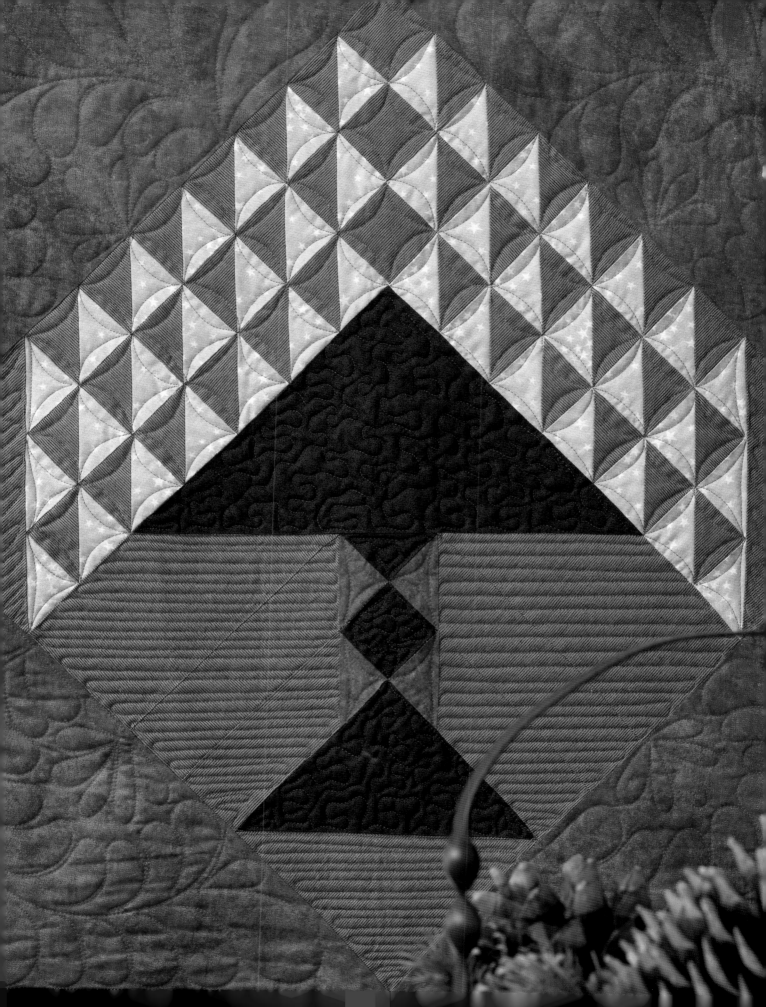

Amish Spring

The Quilts

Spring Breeze

Blowing gently in the breeze of an

Amish spring, Bearpaw Blocks

ripple in rows of alternating colors

on a quilt that blends beautifully

into the green landscape.

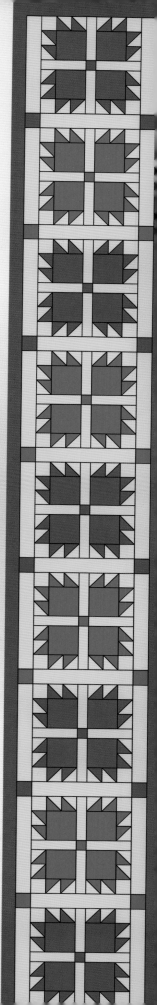

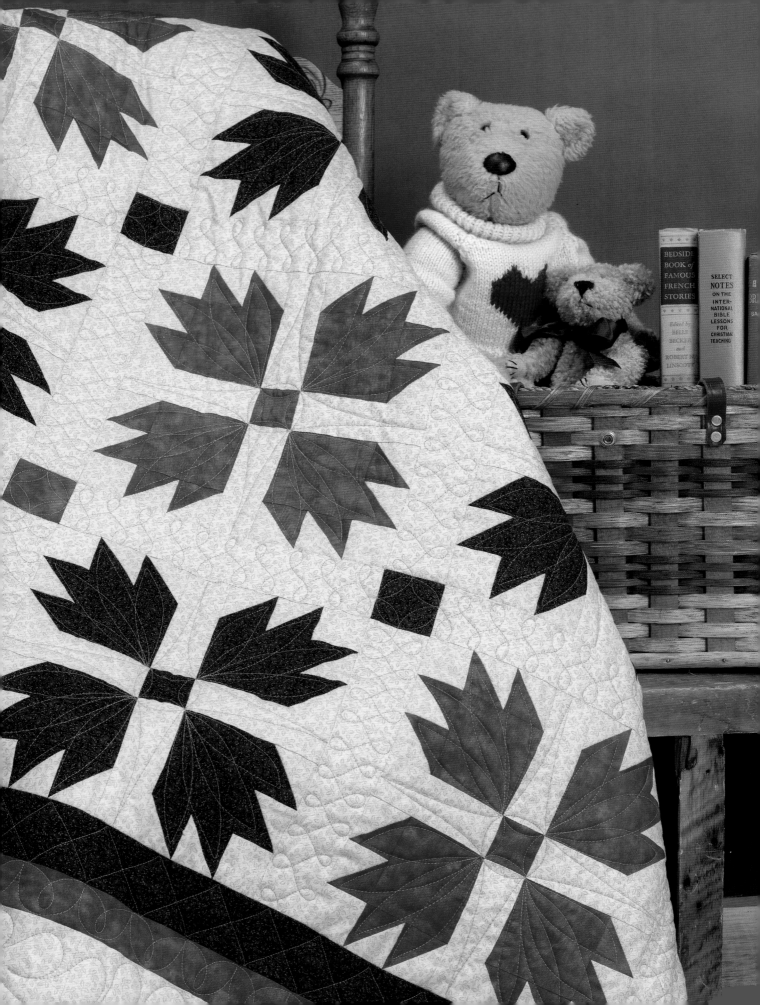

Spring Breeze

Approximate finished size:
77-1/2" x 102-1/2"

Materials

6-1/2 yards of gold fabric for
background, sashing and borders

3-1/2 yards of rust for blocks, corner
stones, borders and binding

2-1/2 yards of dark green fabric for
blocks, corner stones and border

6 yards of backing fabric
(seamed to fit finished top)

Cotton batting to fit finished top

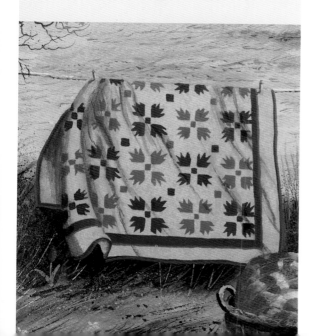

Bear Paw Block

Center Block finished size: 10-1/2" x 101/2"

Make 35 Blocks

Cutting

- From the gold fabric cut:
 7—2" x 44" strips; cut strips to make
 140—2" squares
 18—2-3/8"x 44" strips; cut strips to make
 280—2-3/8" squares
 cut in half diagonally once to make
 560—2-3/8" half-square triangles
 4—5" x 44" strips; cut strips to make
 70—2" x 5" rectangles
 4—5" x 44" strips

- From the rust fabric cut:
 6—3-1/2" x 44" strips; cut strips to make
 68—3-1/2" squares
 9—2-3/8"x 44"strips; cut strips to make
 136—2-3/8" squares
 cut in half diagonally once to make
 272—2-3/8" half-square triangles
 1—2" x 44" strip

- From the dark green fabric cut:
 6—3-1/2" x 44" strips; cut strips to make
 72—3-1/2" squares
 9—2-3/8" x 44" strips; cut strips to make
 144—2-3/8" squares
 cut in half diagonally once to make
 288—2-3/8" half-square triangles
 1—2" x 44" strip

Assembling the Bear Paw Block

1. Using a 1/4" seam allowance, sew the 272 rust 2-3/8"
 half-square triangles and the 288 dark green 2-3/8"
 half-square triangles, and the 560 gold 2-3/8"
 half-square triangles into triangle squares as shown.

Make 272 *Make 288*

2. Using 136 rust and 144 dark green triangle squares make Unit A.

Make 68 *Make 72*

Unit A

3. Using the 140 gold 2" squares and the 136 rust and 144 dark green triangle squares make Unit B.

Make 68

Make 72

Unit B

4. Join Units A and B to the rust and dark green 3-1/2" squares forming a Bear Paw. Pieces should measure 5" square to each unfinished edge.

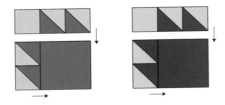

5. Join Bear Paw with 70 gold 2"x 5" rectangles. Make 34 rust and 36 dark green half blocks.

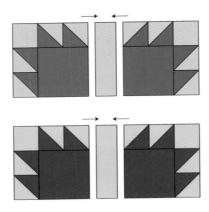

6. Make one strip set each using the gold 5" x 44" strips and the rust and dark green 2" x 44" strips, as shown. Cut 17—2" rust pieces and 18—2" dark green pieces, as shown for Unit C.

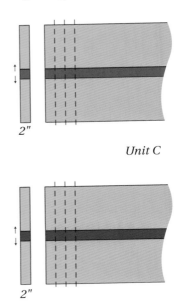

Unit C

7. Using the Bear Paw half blocks and Unit C, sew into 17 rust Bear Paw Blocks and 18 dark green Bear Paw Blocks. Blocks should measure 11" square to each unfinished edge.

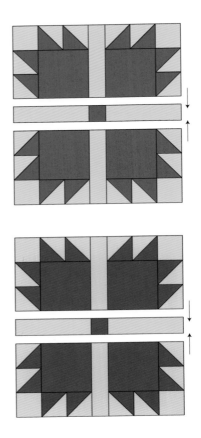

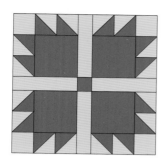

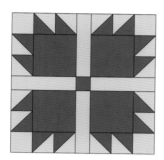

Assembling the Sashing

Cutting

- From the gold fabric cut:
 6—11" x 44" strips, cut 4 strips into
 34—2" x 11" rectangles

- From the rust fabric cut:
 1—2" x 44" strip

- From the dark green fabric cut:
 1—2" x 44" strip

1. Sew one strip set each using the two gold
 11" x 44" strips and rust and dark green
 strips as shown. Cut 12—2-1/2" Sashing Units
 from each set.

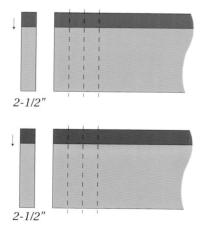

2-1/2"

2-1/2"

2. Make three sashing strips using the Sashing
 Units and 2" x 11" gold rectangles.

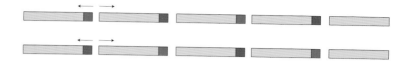

Assembling the Quilt Top

1. Sew four rows of rust and dark green Bear Paw
 Blocks and gold rectangles together.

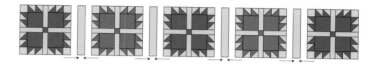

2. Sew three rows of rust and dark green Bear Paw
 Blocks and gold rectangles together. Press.

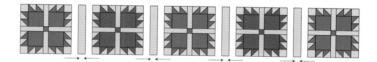

3. Join the rows with the Sashing Units following
 the illustration.

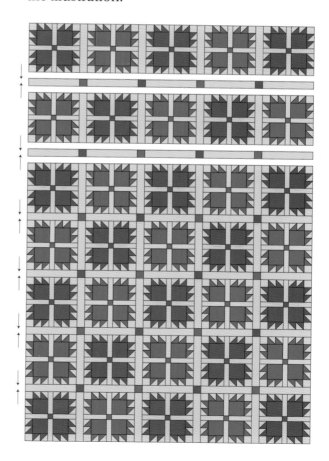

Assembling the Borders

• From the dark green fabric cut:
 8—2-1/2" x 44" strips

1. Seam the strips as needed to make two 86" border strips. Sew to sides of the quilt top.

2. Seam the strips as needed to make two 65" border strips. Sew to top and bottom of the quilt top.

• From the rust fabric cut:
 8—2" x 44" strips

1. Seam the strips as needed to make two 90" border strips. Sew to sides of the quilt top.

2. Seam the strips as needed to make two 68" border strips. Sew to top and bottom of the quilt top.

• From the gold fabric cut:
 9—5-1/2"x 44" strips

1. Seam the strips as needed to make two 93" border strips. Sew to sides of the quilt top.

2. Seam the strips as needed to make two 78" border strips. Sew strips to top and bottom of the quilt top.

Finishing

1. Layer quilt top with batting and backing. Quilt as desired.

2. Refer to General Instructions to bind quilt with red fabric.

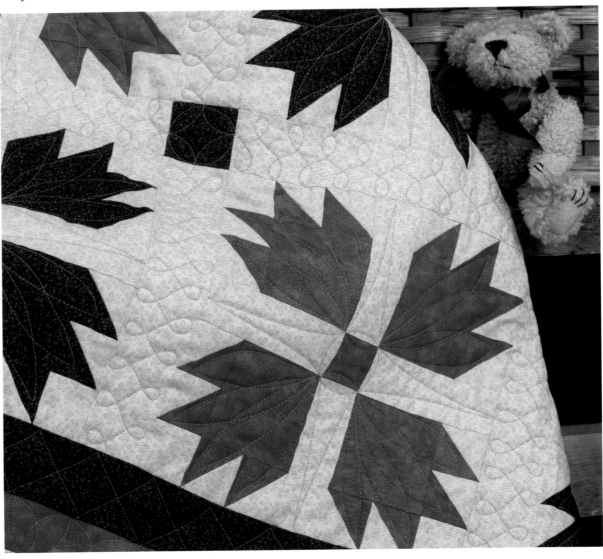

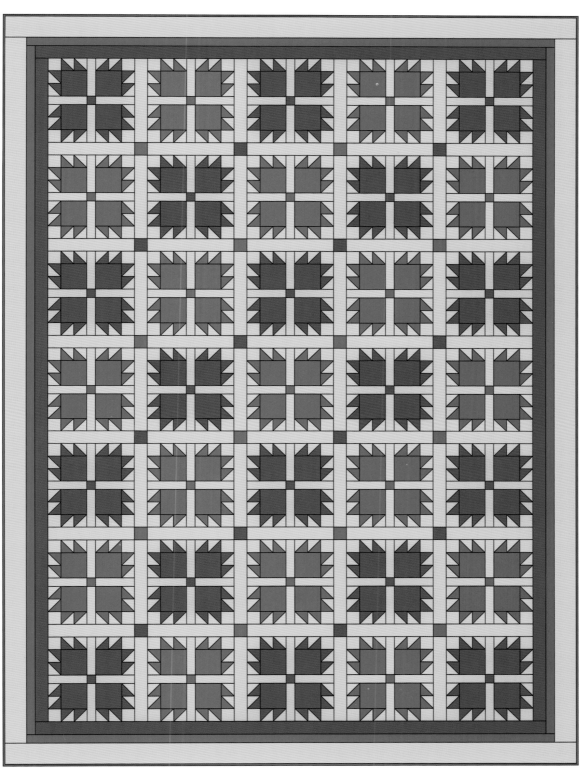

Spring Breeze Quilt

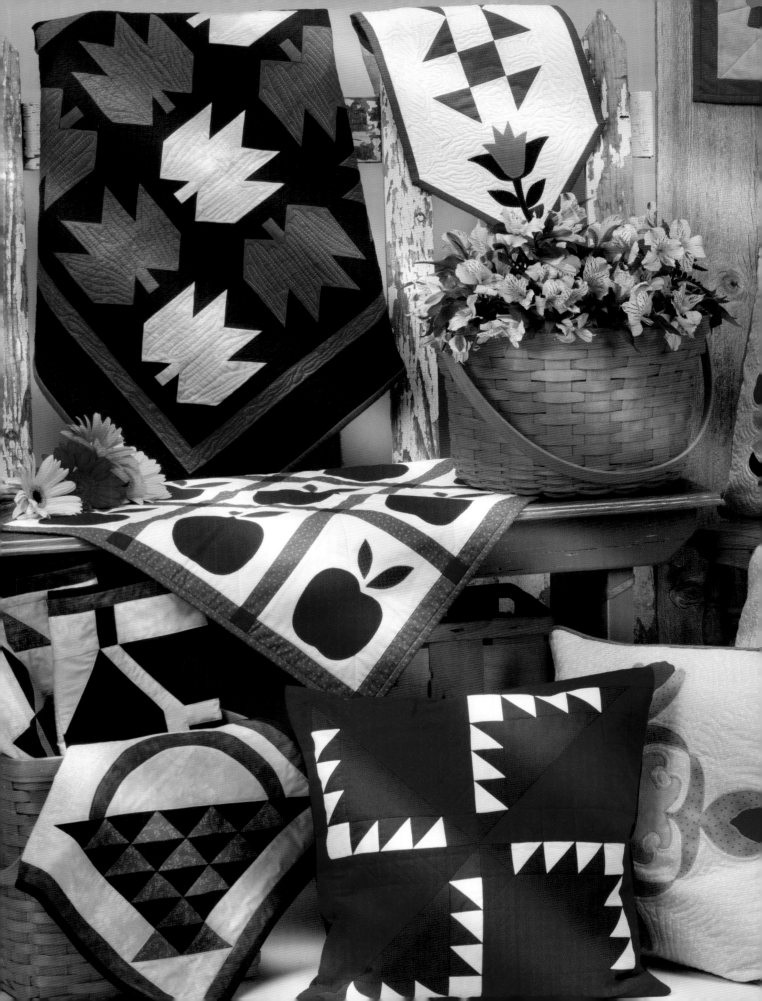

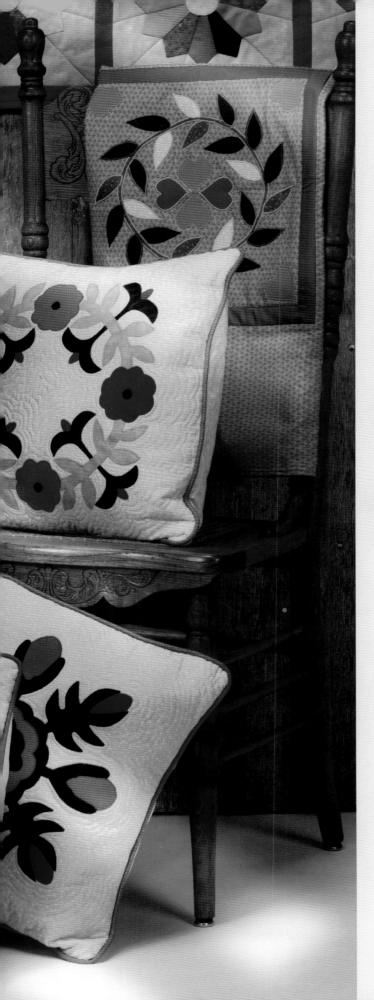

THE PROJECTS

Decorating with artful accents couldn't be easier with more than a dozen accessory projects featuring favorite block motifs from Diane's vibrant watercolor paintings.

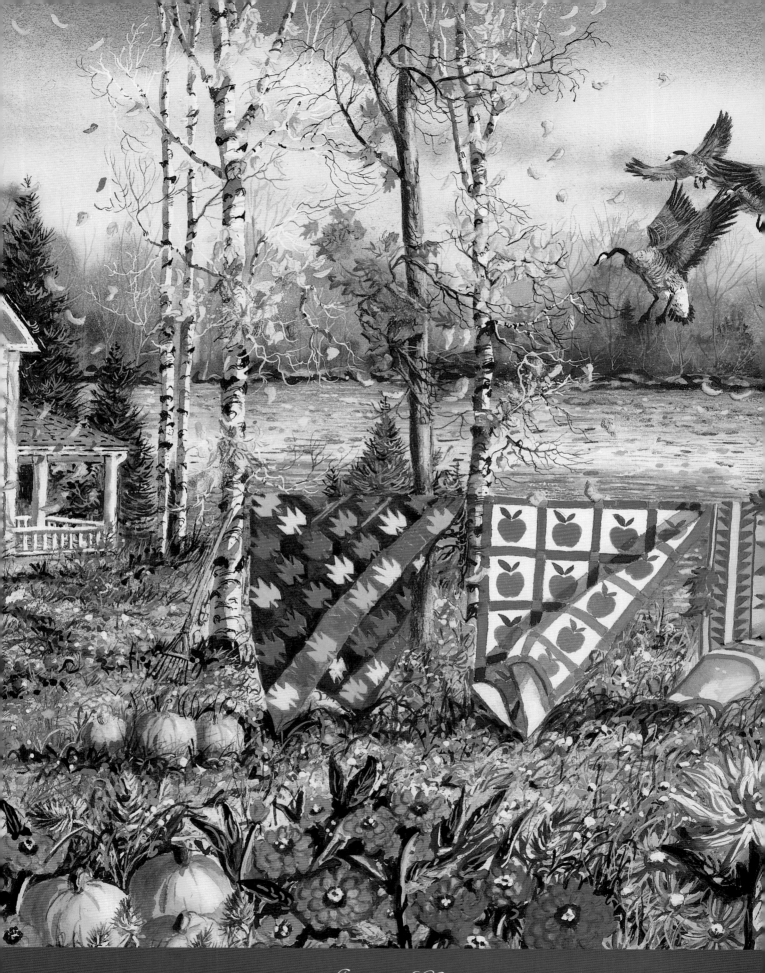

Autumn Glow

Maple Leaf Mist

Paint a picture-perfect autumn table with stylized maple leaves on a generously-sized mat and matching coasters.

Approximate finished size:
30" x 30"

Materials

1/2 yard of orange fabric for leaves

✤

1/3 yard of yellow fabric for leaves

✤

3/4 yard of green fabric
for leaves and binding

✤

1 yard of black fabric for background

✤

1 yard of backing fabric

✤

Cotton batting to fit finished top

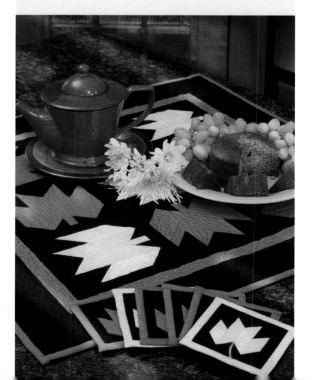

Maple Leaf Block

Block finished size: 6" x 6"

Make 9 Blocks

Cutting

- From the orange fabric cut:
 3—1-1/4" x 3" rectangles
 6—2" x 5-1/2" rectangles
 6—2" x 6-1/2" rectangles

- From the yellow fabric cut:
 3—1-1/4" x 3" rectangles
 6—2" x 5-1/2" rectangles
 6—2" x 6-1/2" rectangles

- From the green fabric cut:
 3—1-1/4" x 3" rectangles
 6—2" x 5-1/2" rectangles
 6—2" x 6-1/2" rectangles

- From the black fabric cut:
 54—2" squares
 18—2" x 3" rectangles

Piecing the Maple Leaves

1. Assemble three leaves from each color using the illustrations below as a guide. Draw a diagonal line from corner to corner on the wrong side of each of the 54—black 2" squares.

2. Right sides together, position a black 2" square on each end of an orange, yellow, or green 2" x 6-1/2" rectangle. Stitch on drawn lines. Trim seam allowance to 1/4". Press. Repeat for other side.

Make 2 per block

3. Right sides together, position a black 2" x 3" rectangle on the left end of an orange, yellow, or green 2" x 5-1/2" rectangle, as shown. Draw a diagonal line. Stitch on the drawn line. Trim seam allowance to 1/4". Press.

4. Right sides together, position a black 2" square on the right end of an orange, yellow, or green 2" x 5-1/2" rectangle. Stitch on the drawn line. Trim seam allowance to 1/4". Press.

Make 1 per block

5. Right sides together position a black 2" x 3" rectangle on the right end of an orange, yellow, or green 2" x 5-1/2" rectangle. Draw a diagonal line. Sew on the drawn line. Trim seam allowance to 1/4". Press.

6. Right sides together, position a black 2" square on the left end of an orange, yellow, or green 2" x 5-1/2" rectangle. Stitch on the drawn line. Trim seam allowance to 1/4". Press.

Make 1 per block

7. Using 1/4" seam allowance, sew the four Leaf sections together.

8. Make and appliqué Stems:

a. Using a 1-1/4" x 3" piece press the top 1/4" to wrong side.

b. Fold, then press top to center.

c. Fold sides to center. Press.

d. Refer to General Instructions to hand or machine appliqué in place.

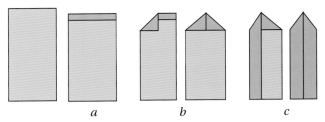

a *b* *c*

Adding the Sashing and Borders

Cutting

- From the black fabric cut:
 4—1-1/2" x 6-1/2" rectangles for sashing
 2—1-1/2" x 20-1/2" rectangles for sashing
 For the First Border
 2—1-1/2" x 20-1/2" border strips
 2—1-1/2" x 22-1/2" border strips
 For the Outside Border
 2—3-1/2" x 24-1/2" border strips
 2—3-1/2" x 30-1/2" border strips

- From the orange fabric cut:
 For the Middle Border
 2—1-1/2" x 22-1/2" border strips
 2—1-1/2" x 24-1/2" border strips

1. Following layout, assemble blocks into rows as shown using the 1-1/2" x 6-1/2" sashing rectangles. Sew rows together.

2. Align and sew each horizontal row with the two 1-1/2" x 20-1/2" sashing rectangles.

3. Sew the First Border (black) to the Maple Leaf Center. Sew the 1-1/2" x 20-1/2" border strips to the sides. Sew the 1-1/2" x 22-1/2" border strips to top and bottom.

4. Sew the Middle Border (orange) to the Maple Leaf Center. Sew the 1-1/2" x 22-1/2" border strips to the sides. Sew the 1-1/2" x 24-1/2" border strips to the top and bottom.

5. Sew the Outside Border (black) to the Maple Leaf Center. Sew the 3-1/2" x 24-1/2" pieces to the sides. Sew the 3-1/2" x 30-1/2" pieces to the top and bottom.

Finishing the Mat

1. Layer quilt top with batting and backing. Quilt as desired.

2. Refer to General Instructions to bind quilt with green fabric.

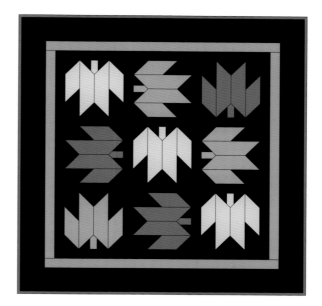

Maple Leaf Coaster

Use the coasters with the mat or by themselves to add a festive autumn touch to any occasion.

Materials

Scraps of orange, yellow, green and black fabric for blocks, backing and binding

❋

6—5-1/2" squares of cotton batting

Maple Leaf Block

Coaster finished size: 4-1/2" x 4-1/2"

Make 2 of each color
(refer to photograph, page 89)

Cutting

• From the orange fabric cut:
 4—1-1/4" x 2-3/4" rectangles
 4—1-1/4" x 3-1/2" rectangles

• From the yellow fabric cut:
 4—1-1/4" x 2-3/4" rectangles
 4—1-1/4" x 3-1/2" rectangles

• From the green fabric cut:
 4—1-1/4" x 2-3/4" rectangles
 4—1-1/4" x 3-1/2" rectangles

Assembling the Leaves

1. Assemble as for large Maple Leaves (see pages 88–89), omitting the Stem.

Finishing the Coaster

1. Layer coaster top with backing and batting. Refer to General instructions to bind coaster with matching fabric.

2. Matching thread to leaf color, machine zig-zag through all layers.

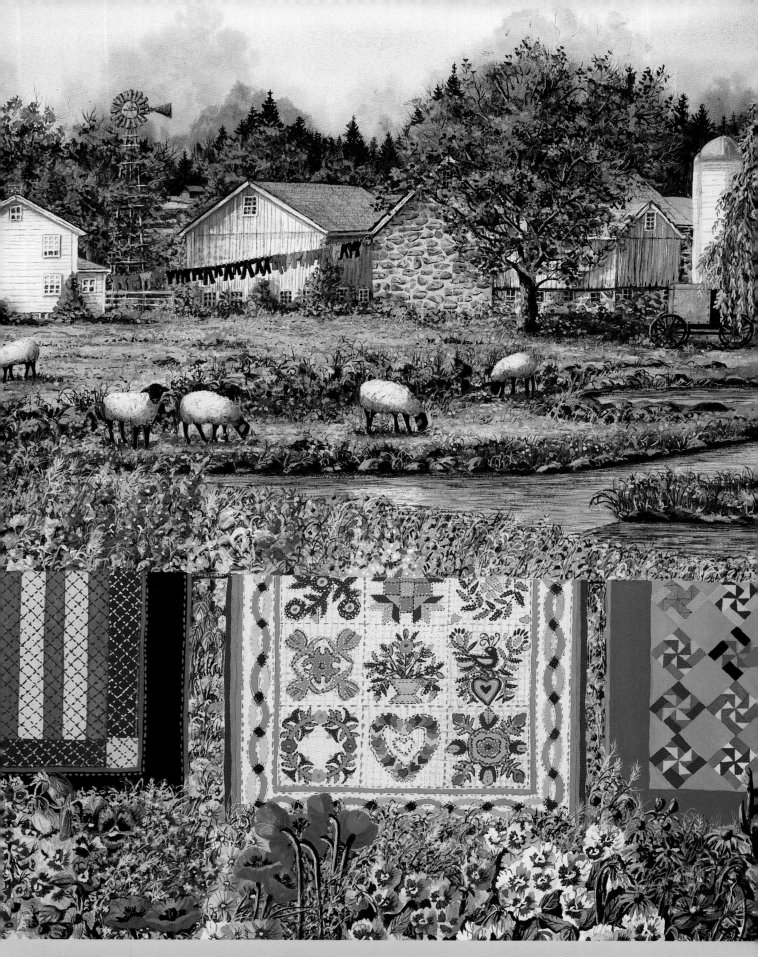

Amish Neighbors

The Projects

An impressive blend of Baltimore Blocks transforms this delightful trio of floral appliqué pillows into perennial favorites.

Approximate finished size:
18" Pillow

Materials

Scraps of pink, light blue, dark blue, and lavender fabric for appliqué

1-3/4 yards of yellow fabric for front and back of pillows

3—18" pillow forms

1/2 yard of fusible web (optional)

6-1/2 yards of prefinished pink piping

3—18-1/2" squares of cotton batting

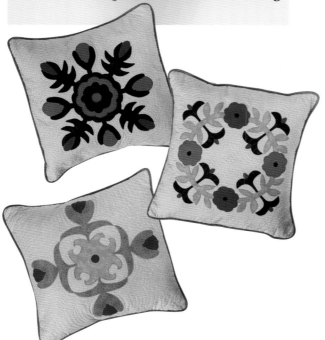

Floral Fantasy

Baltimore Blocks

Block finished size: 18" x 18"

Make 3 Blocks

Cutting

• From the yellow fabric cut:
 3—18-1/2" squares

Assembling Baltimore Blocks

1. Referring to General Instructions for hand or machine appliqué, use the patterns (see pages 94–96) to appliqué each pillow front to the center of the three yellow 18-1/2" squares, as shown.

Finishing the Pillows

1. Layer pillow tops with batting and backing. Quilt as desired.

2. Following manufacturer's instructions, sew piping to outside edge of pillow tops.

3. Following manufacturer's instructions, make pillow back and sew to pillow tops.

93

Full-sized one quarter of appliqué pattern

Full-sized one quarter of appliqué pattern

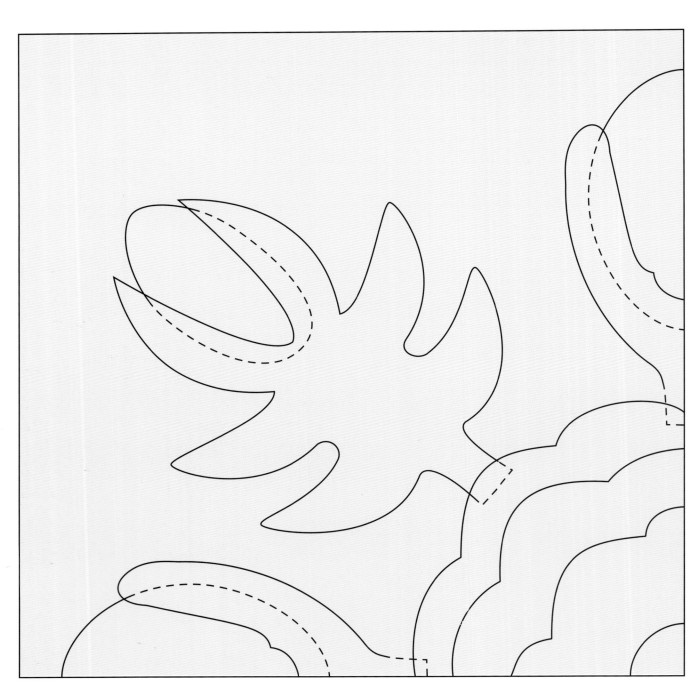

Full-sized one quarter of appliqué pattern

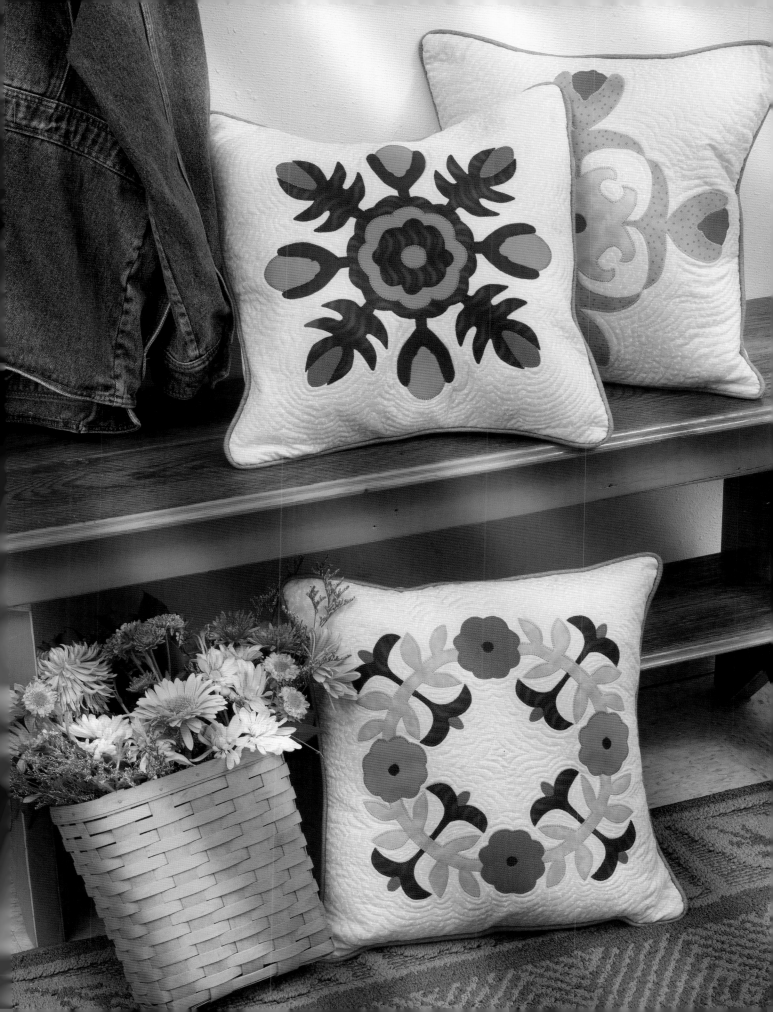

Quilts for Sale

Picket Fence Petals

The Churn Dash Block pattern blooming with color makes this runner a summertime treat.

Approximate finished size: 10" x 33"

Materials

3/4 yard of white fabric
for background

1/2 yard of pink fabric
for Churn Dash Blocks and binding

scraps of pink fabric for flowers

scraps of dark green fabric for leaves

1/2 yard of backing

Fusible web (optional)

Cotton batting to fit finished top

Churn Dash Block

Churn Dash Block finished size: 6" x 6"

Make 3 Blocks

Cutting

• From the white fabric cut:
 12—2-1/2" squares
 6—2-7/8" squares; cut squares in half diagonally
 once to make
 12—2-7/8" half-square triangles

• From the pink fabric cut:
 3—2-1/2" squares
 6—2-7/8" squares; cut squares in half diagonally
 once to make
 12—2-7/8" half-square triangles

Assembling the Block

1. Using 1/4" seam allowances, sew the 12 pink and 12 white 2-7/8" half-square triangle together into 12 triangle square units.

2. Following the illustration make three Churn Dash Blocks. Sew units into rows. Sew rows together.

3. Sew three Churn Dash Blocks together, as shown.

Assembling the Border

Cutting

- From white cut:
 1—8" square; cut in half diagonally once to make
 2—8" half-square triangles
 2—2-1/2" x 10-1/2" rectangles
 2—2-1/2" x 18-1/2" rectangles

1. Sew the two white 2-1/2" x 18-1/2" rectangles to the top and bottom of piece.

2. Sew the two white 2-1/2" x 10-1/2" rectangles to the sides of piece.

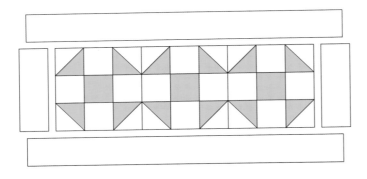

3. Sew the two white 8" half-square triangles to each end as shown.

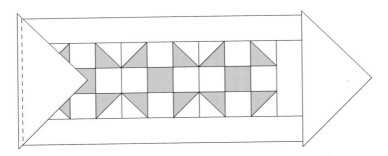

4. Refer to General Instructions to hand or machine appliqué the flowers, stems and leaves to the table runner.

Finishing the Runner

1. Layer top with batting and backing. Quilt as desired. Bind with pink fabric.

2. Refer to General Instructions to bind quilt with pink fabric.

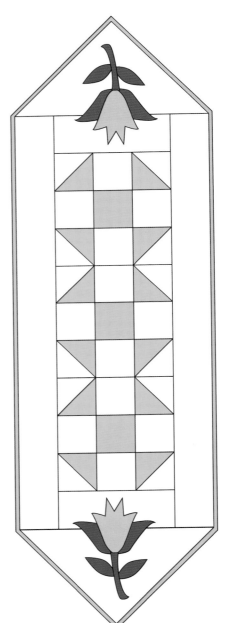

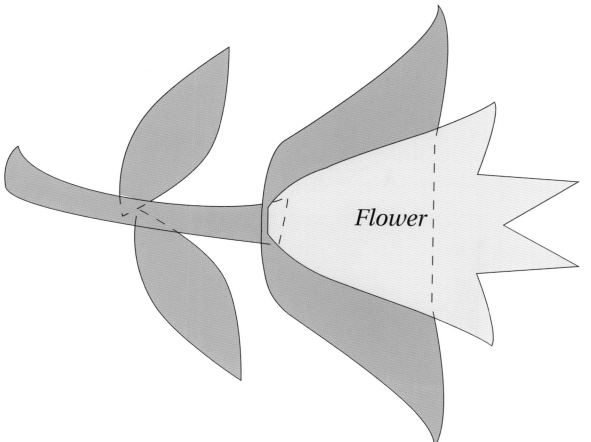

Flower

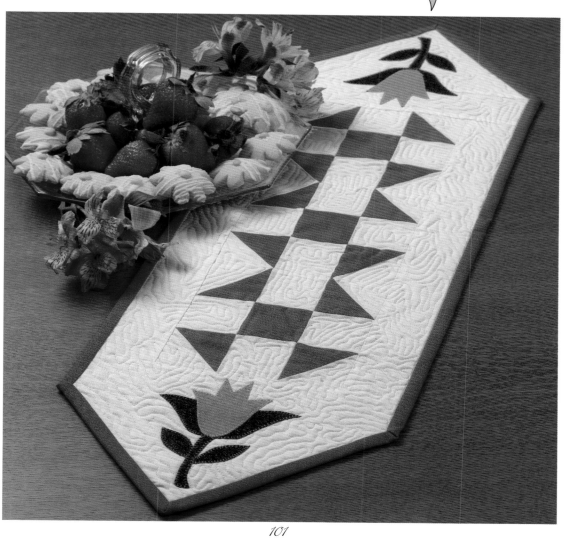

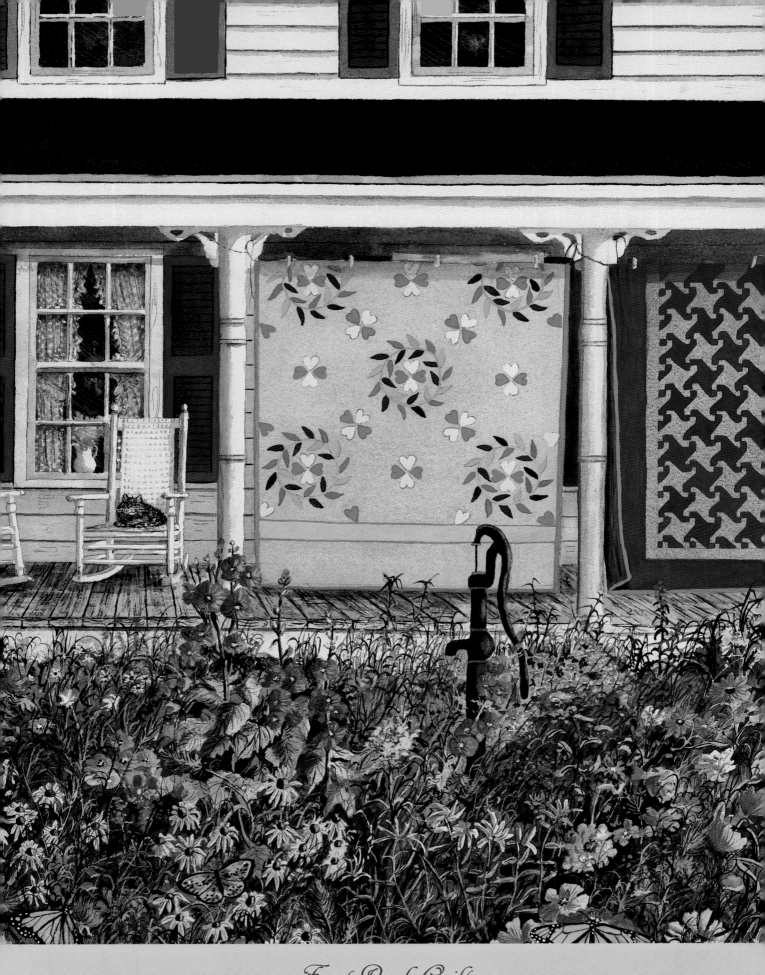

Front Porch Quilts

The Projects

A ring of hearts and flowers comes full circle as a tribute to enduring love on this romantic table topper.

Approximate finished size:
30" x 30"

Materials

Scraps of yellow, green,
blue, and pink fabric for appliqué

1-1/4 yards of gold
fabric for background

1/8 yard of lavender fabric for border

1/2 yard of fusible web (optional)

1 yard of backing

❀

14" square
of thin cotton batting

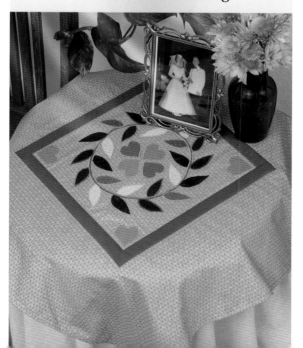

Bridal Wreath Block

Block finished size: 14" x 14"

Cutting

- From the gold fabric cut:
 1—14" square
 2—8-1/2" x 14-1/2" rectangles
 2—8-1/2" x 30-1/2" rectangles

- From the lavender fabric cut:
 2—1-1/2" x 12-1/2" rectangles
 2—1-1/2" x 14-1/2" rectangles

- From the backing fabric cut:
 1—30-1/2" square

Assembling the Block

1. Refer to General Instructions for hand or machine appliqué. Using illustration for placement, center and appliqué design in place on the 14" gold square. Position the 14" square right side up on batting piece and quilt as desired. Trim to 12-1/2" square.

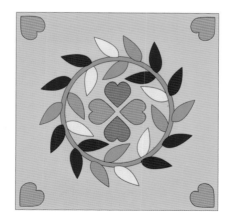

2. Sew the two lavender 1-1/2" x 12-1/2" rectangles to the sides of the center piece. Sew the two lavender 1-1/2" x 14-1/2" rectangles to top and bottom of center piece. Sew the two gold 8-1/2" x 14-1/2" rectangles to sides of piece. Sew the two gold 8-1/2" x 30-1/2" rectangles to top and bottom of piece.

Finishing the Table Topper

1. Lay top and backing right sides together. Using a 1/4" seam allowance stitch around edges as shown, leaving an opening for turning.

2. Turn right side out and press. Slip stitch opening closed. Top stitch 1/4" from outside edge. Stitch in the ditch around center block.

Cut 24 leaves

Cut 8 hearts

Refer to illustration on page 101

for leaf and heart placement

Full-sized one quarter of appliqué pattern

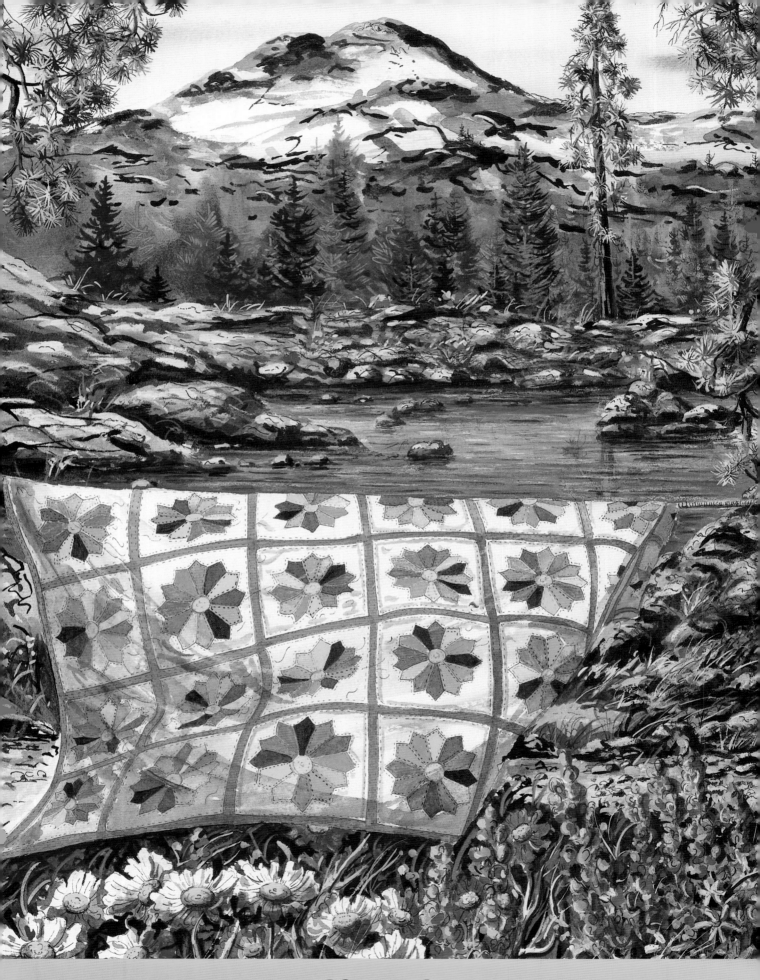

Mountain Breeze

The Projects

Add interest to a nine-patch wallhanging by simply changing the curves to points on the classic Dresden Plate block pattern.

Approximate finished size: 32-1/2" x 32-1/2"

Materials

Scraps of yellow, green, light blue, dark blue, red, pink, gold, lavender and turquoise fabric for Dresden Plate pieces

1 yard of blue fabric for background

3/4 yard of pink fabric for sashing, borders, and binding

1 yard of backing fabric

❖

Cotton batting to fit finished top

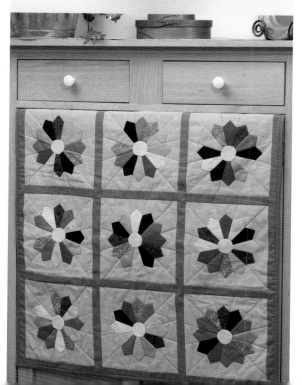

Dresden Plate Block

Block finished size: 9-1/2" x 9-1/2"

Make 9 Blocks

Cutting

• From the scraps of assorted fabric cut:
 108—Template A (page 109)

• From the yellow fabric cut:
 18—Template B (page 109)

• From the blue background fabric cut:
 9—12" squares

Assembling the Block

1. Fold Template A right sides together and sew across wide end. Turn right side out, forming point. Press.

2. Randomly sew colors together by twos until you have six units joined to make Dresden Plate half-units.

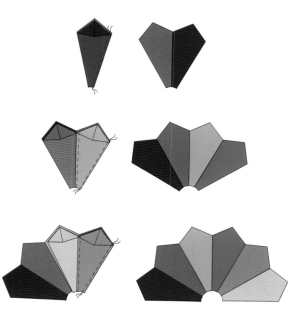

3. Join Dresden Plate half units to make nine Dresden Plate Units.

4. Refer to General Instructions to hand or machine appliqué the nine Dresden Plate Units to the 9—12" blue background squares.

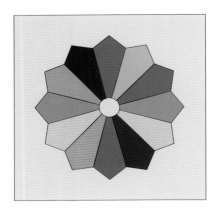

5. Place nine Template B right sides together and sew using 1/4" seam allowances throughout. Carefully cut a slit in one at center. Turn and press. Appliqué in center of Dresden Plate Unit.

6. Trim blocks to measure 10" square.

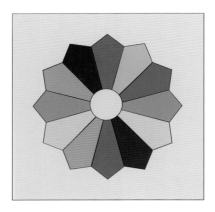

Assembling the Sashing

Cutting

- From the pink fabric cut:
 12—1-1/2" x 10" rectangles
 4—1-1/2" x 33" pieces

1. Following illustration, lay out the blocks in three rows. Join with the 12—1-1/2" x 10" rectangles.

2. Join rows with the 4—1-1/2" x 33" sashing strips.

Finishing the Wallhanging

1. Layer quilt top with batting and backing. Quilt as desired.

2. Refer to General Instructions to bind quilt with pink fabric.

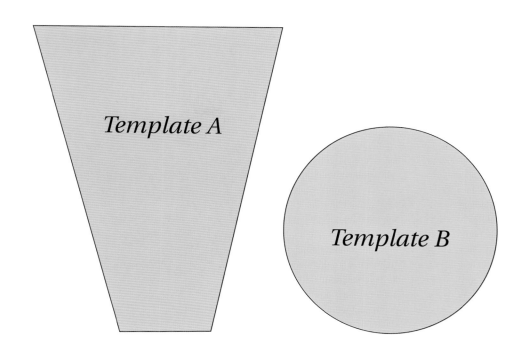

Template A

Template B

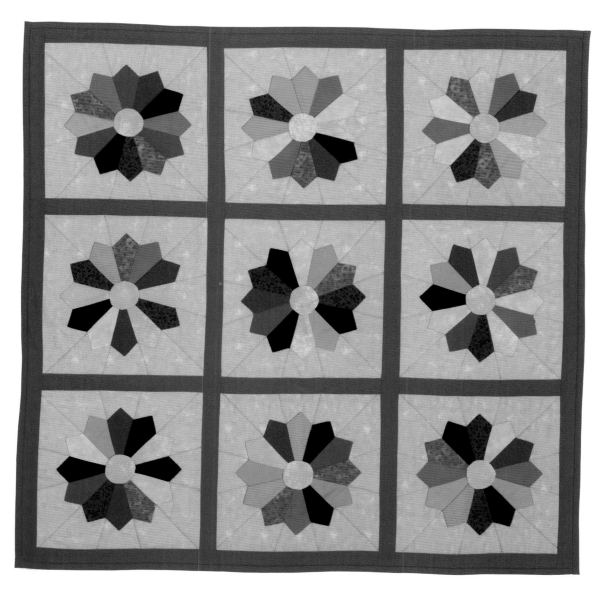

Delectable Mountains

Bear Tracks

The unexpected windmill effect of this modified Bear Paw block puts a new twist on twin pillows.

Approximate finished size:
18" Pillow

Materials

1/2 yard of red fabric
for background and border

1 yard of blue fabric
for blocks and pillow back

1/4 yard of white fabric for blocks

2—18" pillow forms

❁

2—18-1/2" squares of cotton batting

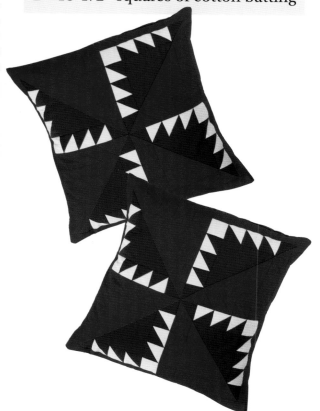

Bear Paw Block

Block finished size: 18" x 18"

Make 8 Blocks

Cutting

- From the red fabric cut:
 4—8-3/8" squares; cut squares in half diagonally once to make
 8—8-3/8" half-square triangles

- From the blue fabric cut:
 32—2-3/8" squares; cut squares in half diagonally once to make
 64—2-3/8" half-square triangles
 4—5-3/8" squares; cut in squares half diagonally once to make
 8—5-3/8" half-square triangles

- From the white fabric cut:
 24—2-3/8" squares; cut squares in half diagonally once to make
 48—2-3/8" half-square triangles
 8—2" squares

Assembling the Block

1. Using a 1/4" seam allowance sew 48—white and 48 blue 2-3/8" half-square triangles together into 48—triangle square units

2. Following illustration make 8—Unit A and 8—Unit B strips.

Unit A

Unit B

3. Following illustration, make eight Bear Tracks Blocks.

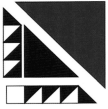

Unit A

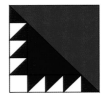

Unit B

4. Sew four blocks together as shown.

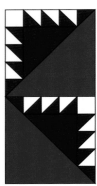

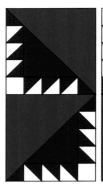

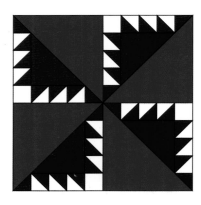

Assembling the Pillow Top

Cutting

• From the red fabric cut:
4—2" x 15-1/2" rectangles
4—2" x 18-1/2" rectangles

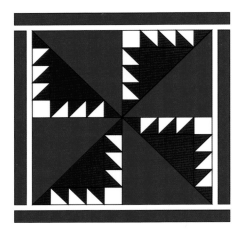

1. Sew two red 2" x 15-1/2" rectangles to sides of block units. Sew two—2" x 18-1/2" rectangles to tops of block units.

Finishing the Pillows

1. Layer quilt top with batting and backing. Quilt as desired.

2. Following manufacturer's instructions, make pillow backs and sew to pillow tops.

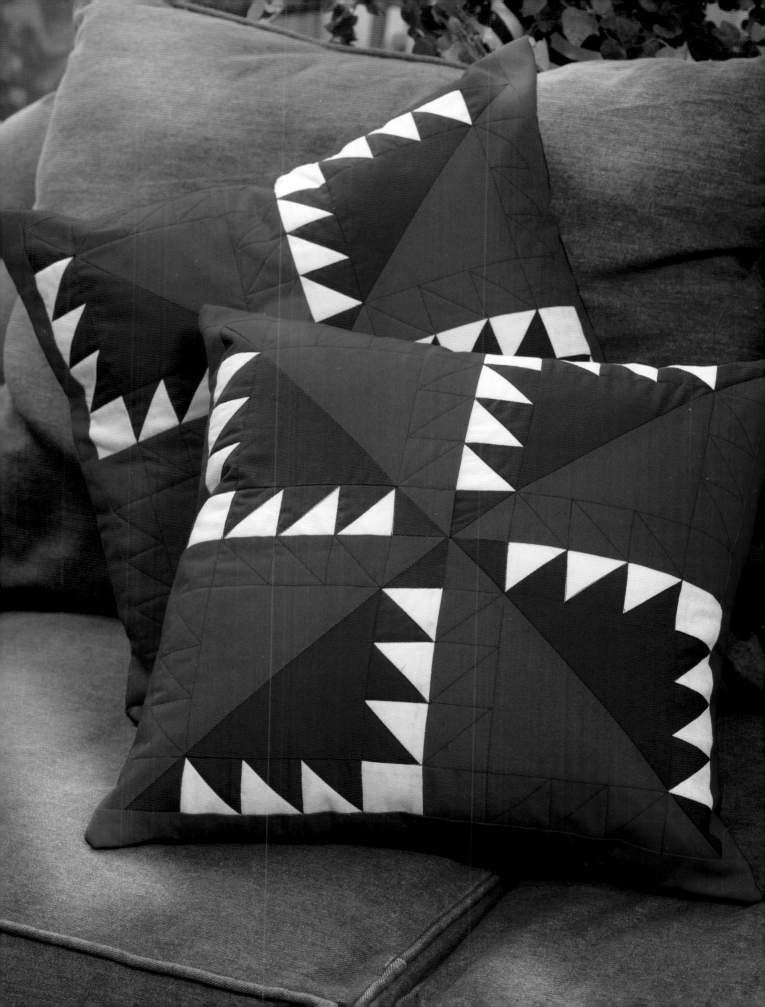

Sisters Sampler

Mix and match classic block patterns for a dramatic sampling of summer's best and brightest placemats.

Approximate finished size:
14" x 20"

Materials

3 yards of yellow fabric
for background and backing

Assorted scraps of purple fabric
for blocks and borders

1 yard of black fabric
for blocks and binding

1/4 yard of fusible web (optional)

4—14-1/2" x 18-1/2" rectangles
of cotton batting

Pine Tree Block

Block finished size: 12" x 12"

Cutting

- From the yellow fabric cut:
 2—2-3/4" squares
 8—3-1/8" squares; cut squares in half diagonally once to make
 16—3-1/8" half-square triangles
 1—4-7/8" square; cut square in half diagonally once for Piece D
 2—4-7/8" half-square triangles
 2—1-1/4" x 11-3/4" rectangles
 2—1-1/4" x 12-1/2" rectangles

- From the purple fabric cut:
 7—3-1/8" squares; cut squares in half diagonally once to make
 14—3-1/8" half-square triangles

- From the black fabric cut:
 1—2-1/2" square; cut square in half diagonally once for Piece C
 2—2-1/2" half-square triangles
 1—1" x 2-3/4" rectangle for Piece B
 1—1" x 3-3/4" rectangle for Piece C
 1—3-1/8" square; cut square in half diagonally once for Piece A
 1—7-5/8" square; cut square in half diagonally once for Piece E

Assembling the Pine Tree Block

1. Using a 1/4" seam allowance sew 14 yellow and 14 purple 3-1/8" half-square triangles into triangle square units.

2. Assemble Unit 1.

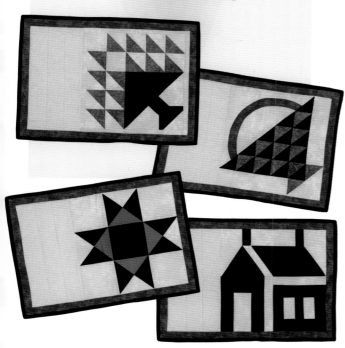

3. Assemble Unit 2.

Unit 2

4. Using the remaining yellow and black pieces, assemble the Trunk/Base Unit.

Trunk/Base Unit

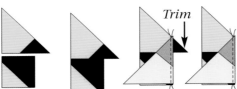

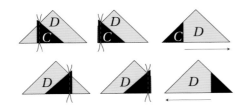

5. Sew the two yellow 1-1/4" x 11-3/4" rectangles to the sides of the Pine Tree Block.

6. Sew the two 1-1/4" x 12-1/2" rectangles to the top and bottom of the Pine Tree Block.

House Block

Cutting

- From the yellow fabric cut:
 2—Template D and
 Template D Reverse (page 121)
 1—Template (page 121)
 2—2-1/2" x 3" rectangles–Piece A
 1—2-1/2" x 5-1/2" rectangle–Piece B
 1—2-1/2" x 5" rectangle–Piece J
 1—1-1/2" x 6-1/2" rectangle–Piece L
 1—1-1/2" x 7" rectangle–Piece K
 2—1-3/4" x 3" rectangles–Piece M

- From the black fabric cut:
 1—Template E (page 121)
 1—Template G (page 121)
 2—1-1/2" x 2-1/2" rectangles–Piece C
 1—2-1/2" x 5" rectangle–Piece H
 2—2" x 5" rectangles–Piece I
 2—1-3/4" x 6" rectangles–Piece M
 2—2" x 4" rectangles–Piece O
 1—1-1/2" x 3" rectangle–Piece N

Assembling the House Block

1. Using 1/4" seam allowances, follow layout and asemble pieces into Units. Sew Units together.

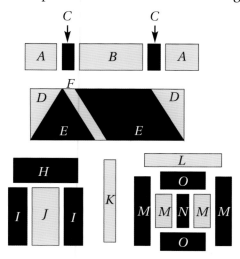

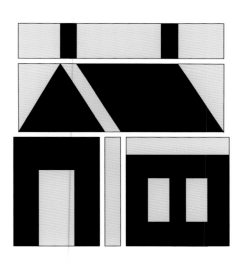

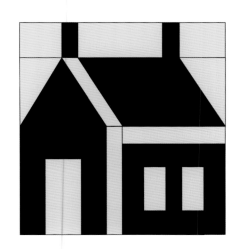

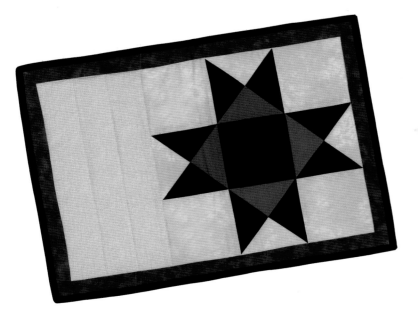

Ohio Star Block

Cutting

- From the yellow fabric cut:
 - 4—4-1/2" squares
 - 1—5-1/4" square; cut square in half diagonally twice to make
 4 quarter-square triangles

- From the purple fabric cut:
 - 1—5-1/4" square; cut square in half diagonally twice to make
 4 quarter-square triangles

- From the black fabric cut:
 - 1—4-1/2" square
 - 2—5-1/4" squares; cut square in half diagonally twice to make
 8 quarter-square triangles

Assembling the Ohio Star Block

1. Using a 1/4" seam allowance sew the yellow, black and purple quarter-square triangles into Units as shown.

2. Sew Units together.

3. Sew Units into rows. Sew rows together.

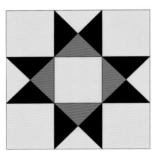

Basket Block

Cutting

- From the yellow fabric cut:
 1—4-7/8" square; cut square in half diagonally once to make

 2—4-7/8" half-square triangles

 1—10-7/8" square; cut square in half diagonally once to make

 2—10-7/8" half-square triangles

 2—2-1/2" x 8-1/2" rectangles

- From the purple fabric cut:
 6—2-7/8" squares; cut squares in half diagonally once to make

 12—2-7/8" half-square triangles

 1—Basket Handle Template (page 120)

- From the black fabric cut:
 8—2-7/8" squares; cut squares in half diagonally once to make

 16—2-7/8" half-square triangles

Assembling the Block

1. Using 1/4" seam allowances sew ten black and ten purple 2-7/8" half-square triangles into triangle square units, as shown.

2. Join into rows with remaining black 2-7/8" half-square triangles, as shown.

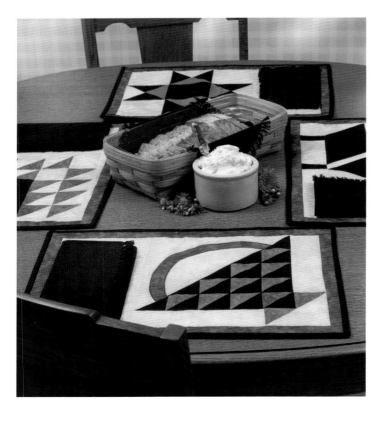

3. Sew the yellow 10-7/8" half-square triangle to the top of the Basket Bottom.

4. Sew remaining purple triangles to the ends of the two yellow 2-1/2" x 8-1/2" yellow rectangles as shown.

5. Sew to sides of block.

6. Sew the remaining yellow 4-7/8" half-square triangle to base of the basket.

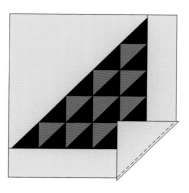

7. Refer to General Instructions to hand or machine appliqué handle to top of basket using Template A (page 120).

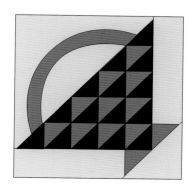

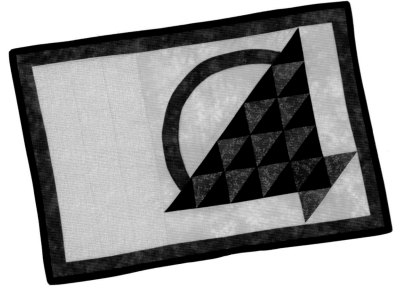

Adding the Borders

Cutting

• From the yellow fabric cut:
 4—6-1/2" x 12-1/2" rectangles
 4—16" x 22" rectangles for backs

• From the purple fabric cut:
 8—1-1/2" x 12-1/2" rectangles
 8—1-1/2" x 20-1/2" rectangles

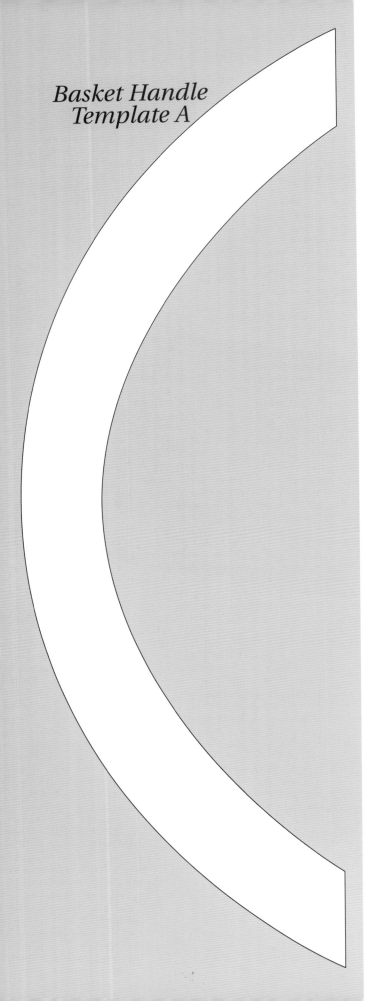

Basket Handle
Template A

1. Sew the yellow 6-1/2" x 12-1/2" rectangles to the left side of each block.

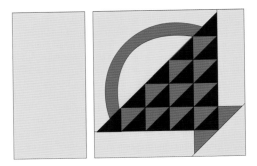

2. Sew two purple 1-1/2" x 12-1/2" rectangles to each side of each placemat.

3. Sew two purple 1-1/2" x 20-1/2" rectangles to the top and bottom of each placemat.

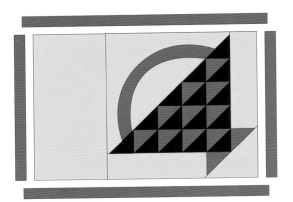

Finishing the Placemats

1. Layer placemat tops with batting and backing. Quilt as desired.

2. Refer to General Instructions to bind each placemat with black fabric.

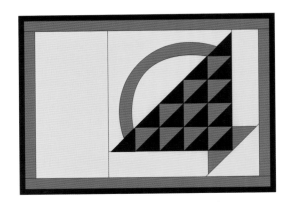

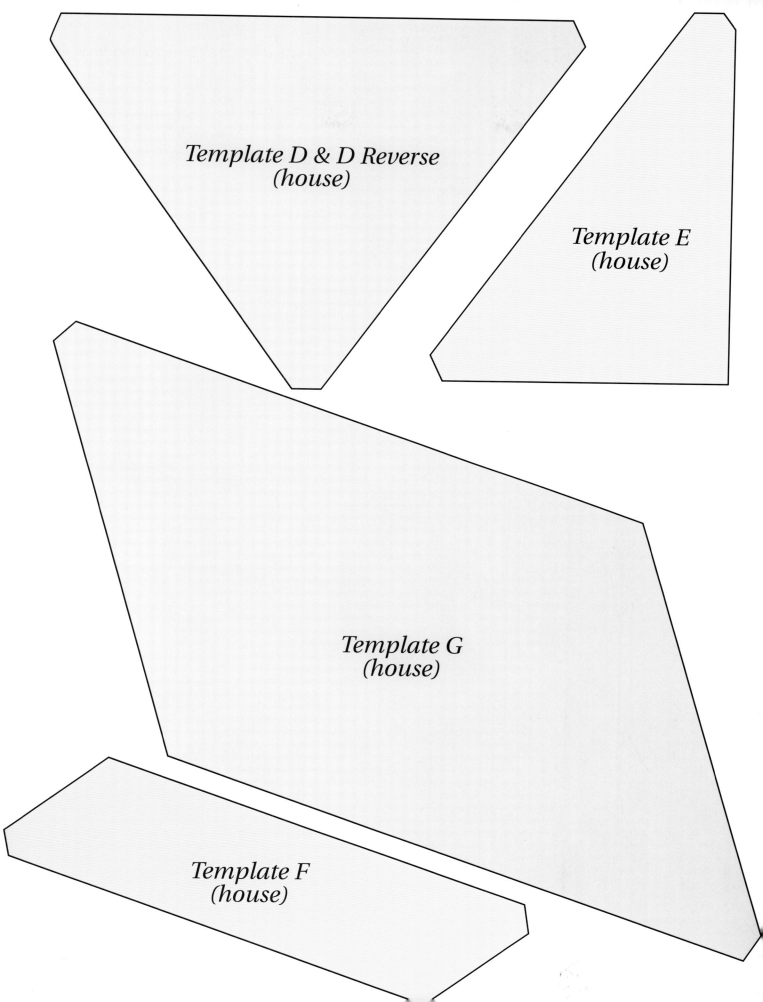

Template D & D Reverse
(house)

Template E
(house)

Template G
(house)

Template F
(house)

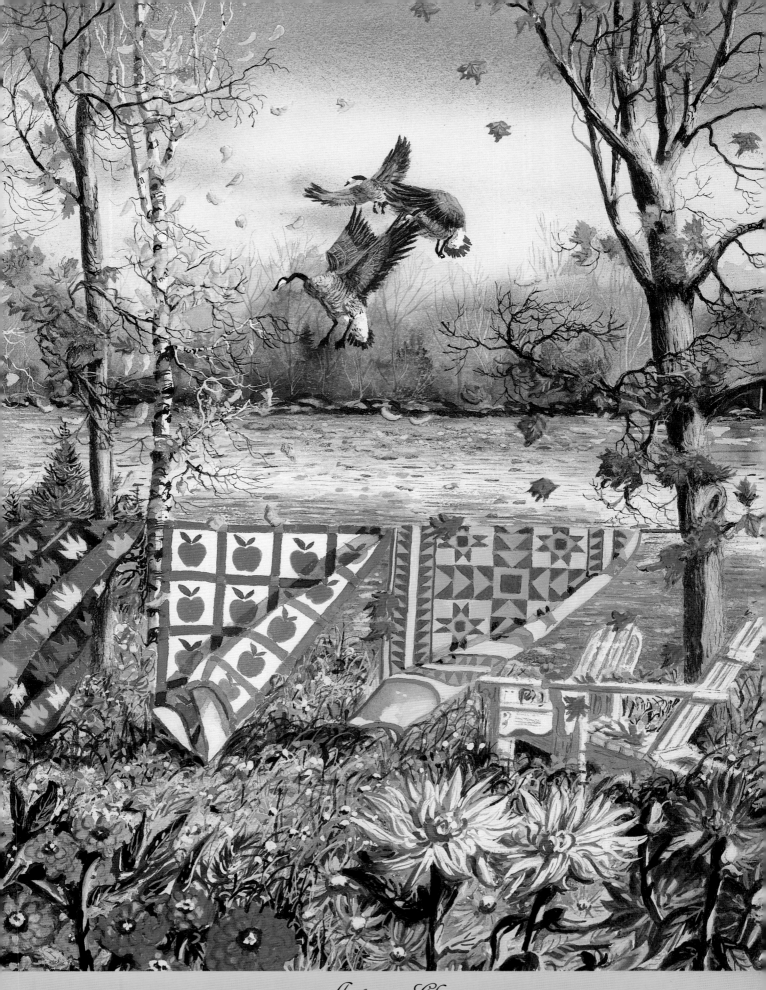

Autumn Glow

Apple Harvest

Usher in autumn with a stunning centerpiece featuring a harvest of apples on a table topper and matching potholder.

Approximate finished size: 22" x 25"

Materials

5/8 yard of white fabric for background

3/8 yard of red fabric for apples

1/4 yard of dark green fabric for leaves

1-1/2 yards of light green fabric for sashing and binding

3/4 yard of fusible web (optional)

1 yard of backing fabric

Cotton batting to fit finished top

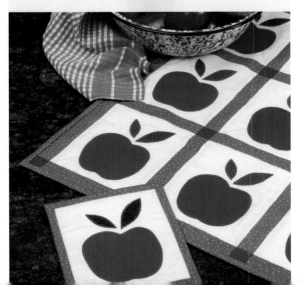

Apple Block

Block finished size: 6" x 7"

Make 9 Blocks

Cutting

- From the white fabric cut:
 9—6-1/2" x 7-1/2" rectangles

- From the red fabric cut:
 9—Template A pieces (on page 125)
 (1 piece per block)

- From the dark green fabric cut:
 9—Template B pieces (on page 125)
 9—Template C pieces (on page 125)
 (1 piece each per block)

Assembling the Apple Block

1. Refer to General Instructions for hand or machine appliqué. Appliqué apples and leaves to center of the nine 6-1/2" x 7-1/2" rectangles.

Adding the Sashing and Corner Stones

Cutting

- From the green fabric cut:
 12—1-1/2" x 6-1/2" rectangles
 12—1-1/2" x 7-1/2" rectangles

- From the red fabric cut:
 16—1-1/2" squares

1. Make four horizontal sashing strips using 1-1/2" x 6-1/2" light green rectangles and red squares.

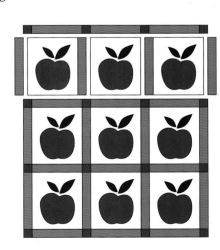

2. Sew 1-1/2" x 7 1/2" green rectangles to Apple Blocks as shown.

3. Sew Apple Block rows to horizontal sashing strips following layout.

Finishing the Table Topper

1. Layer quilt top with batting and backing. Quilt as desired.

2. Refer to General Instructions to bind with green fabric.

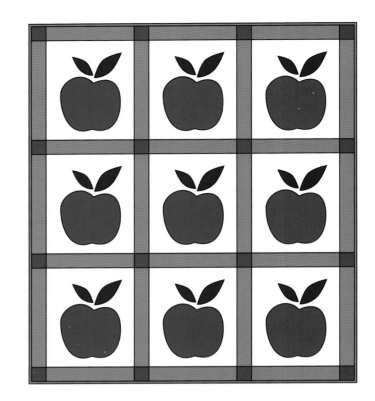

Apple Potholder

Materials

Scraps of red, green and white fabric

2—7-1/2" x 8-1/2" squares of cotton batting

Note: If desired, add 2 layers of batting to each potholder.

Apple Block

Potholder finished size: 7" x 8"

Cutting

• From the white fabric cut:
 2—7-1/2" x 8-1/2" rectangles

Assembling the Block

1. Cut and sew two Apple Blocks as described for table topper.

Finishing the Potholder

1. Layer potholder top with batting and backing. Quilt as desired.

2. Refer to General Instructions to bind with green fabric.

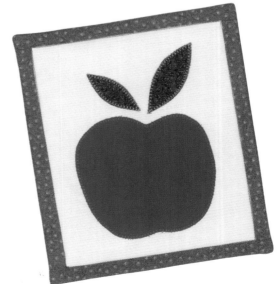

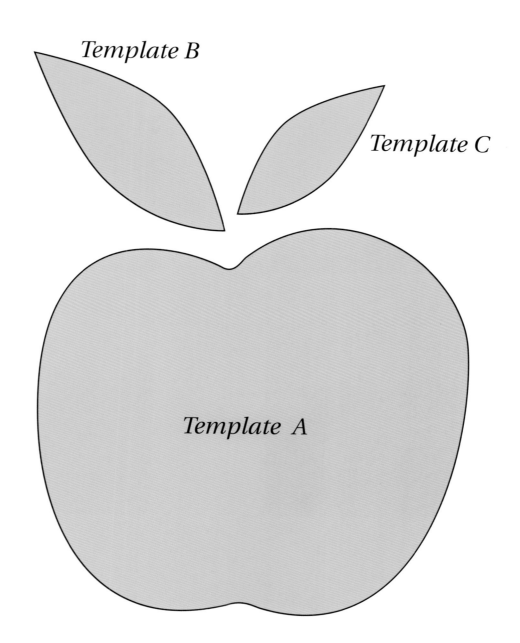

Template B

Template C

Template A

THE GALLERY

For more about Diane Phalen
Watercolors visit her website
at www.dianephalen.com or
call 800-832-3463.

Delectable Mountains

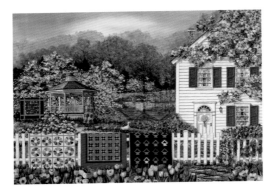

Spring Garden

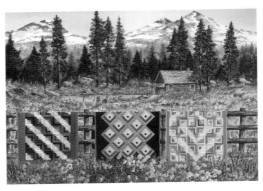

Log Cabin Quilts

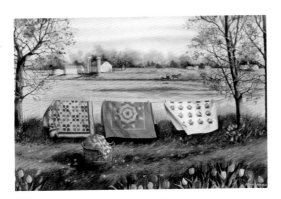

Amish Spring

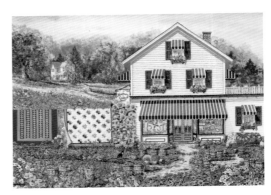

September Gold

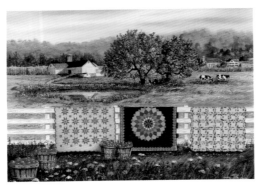

Amish Roadside Market

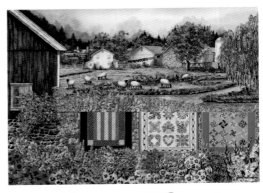

Amish Neighbors